ILLUSTRATED TALES OF
CORNWALL

JOHN HUSBAND

AMBERLEY

For Finley and Nora

First published 2024

Amberley Publishing
The Hill, Stroud
Gloucestershire, GL5 4EP

www.amberley-books.com

British Library Cataloguing in Publication Data.
A catalogue record for this book is available from the British Library.

ISBN 978 1 3981 1327 5 (paperback)
ISBN 978 1 3981 1328 2 (ebook)

Origination by Amberley Publishing.
Printed in Great Britain.

Contents

Introduction

Cornwall has been marketed as the 'Land of Legend' ever since tourists began to visit in the Victorian era. From epic tales of chivalry and romance, like those of King Arthur or Tristan and Isolde, to myths of giants, piskies, saintly miracles and mermaids, library shelves have been filled with numerous volumes recording tales of Cornwall. Before the Victorian era, this heritage was kept alive by wandering minstrels known as droll tellers, who travelled around the West Country entertaining with music and stories in return for bed and board. By the mid-nineteenth century such characters had almost died out, and one, Henry Quick, wrote an epitaph to the profession blaming the march of science:

> *The Cornish Drolls are dead, each one,*
> *The fairies from their haunts have gone,*
> *There's scarce a witch in all the land,*
> *The world has grown so learn'd and grand.*

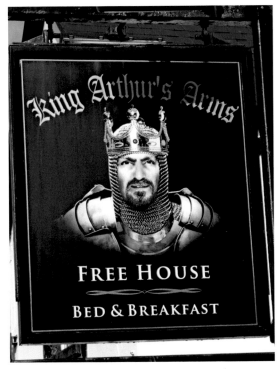

Commercialisation of the legend of King Arthur at Tintagel.

We must be grateful that Victorian writers like Robert Hunt realised what would be lost and spent time recording them, 'drinking deeply from the stream of legendary lore' as he put it. He published his *Popular Romances of the West of England* in 1865, and was followed by other writers, for example William Bottrell who published three volumes of tales between 1870 and 1880. Other authors including Revd Sabine Baring Gould and Sir Arthur Quiller-Couch ('Q') published accounts of the lives of more recent Cornishmen and women of note, or indeed, notoriety. Today, many of these legends have been commercialised to attract tourists, as a visit to honeypot villages like Tintagel or Polperro will show.

In planning this book, I have included a range of Cornish tales, some essential well-known ones, others which I hope will be new to the reader. I have sought to include some modern twists where possible. Beginning with legends of kings, giants, piskies and Cornish saints, there are tales of the sea, tales of the moors and tales associated with the county's fishing and mining past. Our appetite for crime stories means that crime and punishment features heavily as well. Some of the stranger village and pub names hold a hidden story, and finally, there are the simply bizarre 'would you believe it' incidents which can be found in local newspaper archives.

I

Legends

Arthur and the Custard King

There is no more famous tale of Cornwall than that of King Arthur, who has been associated with Tintagel ever since writings by Geoffrey of Monmouth in the twelfth century. Arthur is said to have been born at Tintagel, the son of Uther Pendragon, King of Britain and Queen Igerna, who had been seduced using some magic from advisor Merlin. Merlin's advice was to raise Arthur in secret and he devised a cunning plan to make him Uther's successor, involving setting a sword in a stone which only Arthur would be able to pull out. As king, Arthur with his Twelve Knights of the Round Table took up his trusty sword Excalibur, which rose from the lake (Dozmary Pool in Cornish legend), against the invading Saxon army, as well as despatching mythical giants, one of whom was hurling rocks at St Michael's Mount. As long as Arthur held the scabbard of Excalibur he would never die in battle, but picking up a spear instead of the sword led to his defeat at the hands of his evil son Mordred, in a fight which killed them both, legend has it at Slaughterbridge near Camelford. He was taken wounded to the Isle of Avalon (possibly Lundy) where he died, his soul passing to the red-billed Cornish chough.

It may surprise visitors to learn that today, true devotees of the Arthurian legend do not head for Tintagel Castle, but instead to a Victorian house in Fore Street. This ordinary-looking building hides one of the greatest architectural

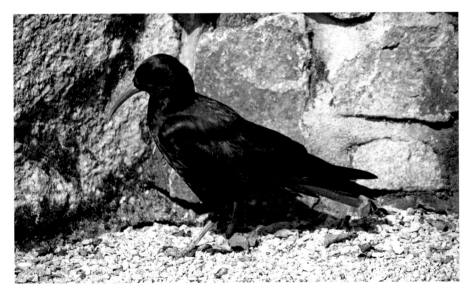

A Cornish chough bred in captivity, Paradise Park, Hayle.

surprises you can find in the county, King Arthur's Great Halls. It was the vision of Frederick Thomas Glasscock, who founded the Order of the Fellowship of the Knights of the Round Table in Tintagel in 1927. Glasscock was co-owner of Monk and Glass, who made custard powder and other desserts in turn-of-the-century Clerkenwell. His business partner was John Monkhouse, grandfather of comedian Bob Monkhouse. During the early part of the twentieth century, Glasscock spent holidays in Tintagel, staying at the exclusive Tintagel Castle Hotel which afforded magnificent views of the castle itself from across the valley. It is likely that these stays began a lifelong obsession with the Arthurian legend. In 1920, Glasscock sold his share of the business and moved to Tintagel where he bought the nineteen-room Gothic property, then called Trevena House, which had an extensive garden at the rear. His vision was to convert it into a hall which would celebrate Arthurian ideals, sparing no expense in the process. Building began in 1927, employing local builders and bringing in specialist craftsmen as required. First to be built was a council chamber, constructed within the house itself, in which the Fellowship would hold meetings. To adorn its medieval-style panelled walls, Glasscock commissioned artist William Hatherell, a well-known historical illustrator of the day, to produce ten oil paintings depicting scenes from the story of King Arthur.

In 1930, work began on the Hall of Chivalry, later renamed the Great Exhibition Hall, adjoining the chamber, and which Glasscock built on the garden plot of Trevena House. Stonemasons from Bodmin were used to fashion the fifty-three types of Cornish stone used to decorate the interior, including 125 shields ranging in tone from dark to light, which decorate the walls of the hall.

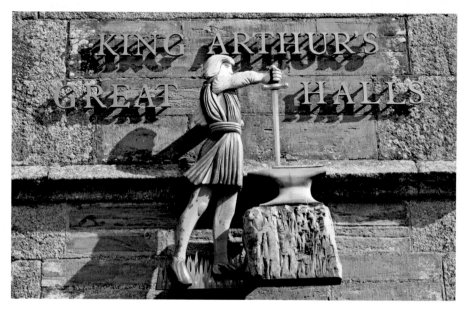

King Arthur's Great Halls exterior, Tintagel.

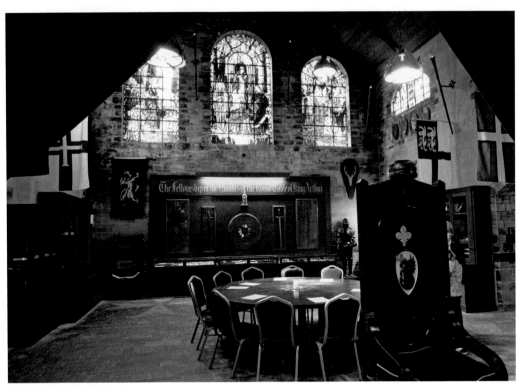

Above and below: The Hall of Chivalry, now the Great Exhibition Hall.

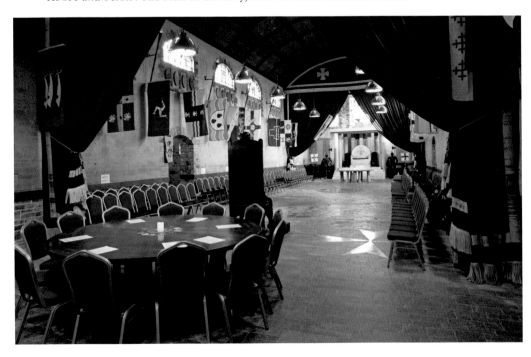

The floor was laid using Polyphant stone from Launceston, and a series of granite thrones weighing 20 tonnes were hewn from Cornish granites, not forgetting, of course, a massive round table using a further tonne of granite. This breathtaking room was completed in 1933 with seventy-three stained-glass windows by Arts and Crafts illustrator Veronica Whall, and forms the largest collection of her work in existence. Her only known secular pieces, she was first commissioned to produce six large windows depicting scenes from King Arthur's life. This led to a further request for eighteen smaller ones representing Virtues of Chivalry, and another forty-nine windows depicting various symbols and badges of the Order. At the same time as supervising the building work, Frederick Glasscock made several trips abroad, mainly to the USA, recruiting new members to the order.

There was an elaborate opening ceremony amid much publicity in June 1933. This was widely reported in the national newspapers, who all seemed to have sent a reporter to Tintagel. After suitably heroic opening music by Wagner, members of the order paraded in, led by a white-robed Glasscock who took his seat on the central throne. Speeches, Bible readings and hymns followed, emphasising the Christian basis of the order's Arthurian ideals. A representative from the USA even attended, his ship having docked in Plymouth at 3 a.m. that morning.

In 1934 Glasscock, then aged sixty-three, accompanied by his wife and an assistant, made a further recruiting trip to America, and on the return voyage aboard the liner *Scythia*, he collapsed and died and was buried at sea. By this time the order had amassed some 17,000 members, with branches in the USA, Canada and Australia, but without Glasscock it declined and was wound up in 1937. His wife inherited ownership of the halls, and his former custard business continued into the 1950s, when it was taken over by competitors Bird's. The Halls were later acquired by the newly formed Tintagel lodge of the Freemasons and became

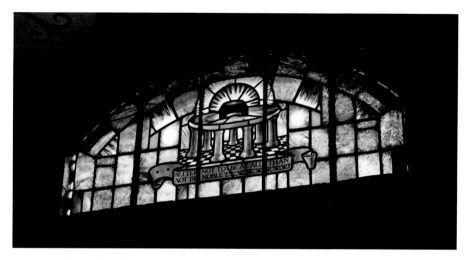

Round Table window by Veronica Whall.

a Masonic Hall in 1952. Now a Grade II* listed building, it has been a tourist attraction since the 1990s when the Order was also revived, and meetings and grand dinners of the Fellowship still take place annually. It is open to the public during the summer months.

Tristan and Isolde (Tristram and Iseult)

This medieval legend has been dramatised in music, art and literature, but its connection with Cornwall is less widely known. One version of the legend was translated by Thomas of Britain from the writings of Gottfried von Strassburg. In a nutshell, Tristan, the nephew of King Mark of Cornwall, kills Morholt, brother of the Queen of Ireland and in the process is mortally wounded. Doomed to die, he is sent out to sea in a boat without sails. Instead of drifting to his death, the boat is washed ashore again and Tristan is rescued and nursed back to health by Isolde, the daughter of the Queen. Unable to remain in Ireland, he returns to Cornwall and to his uncle King Mark. In due course Mark, hearing Tristan's story of the beautiful princess who restored his life, resolves to marry her and sends Tristan back to Ireland to bring her back to him as his bride. The web becomes more tangled when, on the voyage back, Tristan and Isolde drink a love potion intended for Mark's wedding night. In a plot worthy of a television soap opera, the couple fall headlong in love, but nevertheless Isolde goes through with the wedding to Mark. The affair is discovered and Tristan is banished to Brittany where in due course he meets and marries (confusingly) a different Isolde. Tristan is again wounded in a fight and sends for Mark's Isolde to come and heal his wounds, as she did earlier in Ireland. He sends a messenger with instructions to fly a white sail from his ship if she is aboard, and if not a black sail. Isolde agrees to return to help her former lover, and they set sail having hoisted a white sail. However, Tristan's jealous wife hears of the plan and informs him that a ship is approaching with a black sail. Tristan dies of grief and, on hearing the news, so does Isolde.

Many versions of the legend place the scene of the marriage between Mark and Isolde at the king's palace at Castle Dore, an Iron Age earthwork on private land in the parish of St Sampson overlooking the River Fowey at Golant, in the sixth century. Excavations at Castle Dore have revealed a hill fort dating from 200–400 BC, the inhabitants having connections with Brittany. However, the French poet Beroul locates Mark's palace at Lancien, today known as Lantyan, a mile or two north of Castle Dore, where there is a field named Mark's Gate, part of a farm called Castle Farm. Quiller-Couch believed that Lancien and Castle Dore were all part of Mark's estate. In the opposite direction along the road to Fowey can be found the Tristan Stone, actually the shaft of an ancient Celtic cross inscribed 'Drustanus hic iacit Cunomori Filius', translated as 'here lies Drustan (possibly Tristan) son of Cunomorus'. Historically there is some evidence that Cunomorus was King Mark. This monument originally stood at St Sampson, the lychgate of whose church bears a modern inscription to Tristan

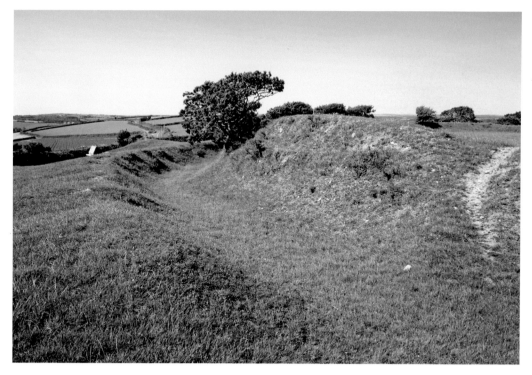

Castle Dore.

The Tristan Stone, Fowey.

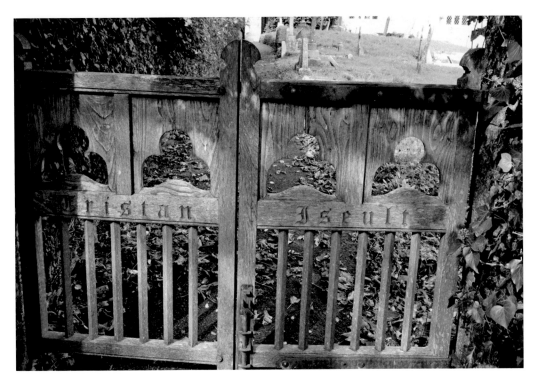

The lychgate, St Sampson.

and Iseult, a nod to the legend that Isolde took communion at this holy site. St Sampson lies on the long-distance route used by pilgrims to travel from Ireland via Wales to Cornwall, then onwards via the port of Fowey to Brittany. Another site which Beroul associated with the legend is at Malpas near Truro, an ancient ferry crossing, where Tristan carried Isolde across the river on his shoulders.

Mermaids

Mermaid legends crop up frequently in Cornwall, often to explain the silting up of previously deep harbours. Such a story is associated with Padstow, beside the mouth of the River Camel in north Cornwall. Here the infamous Doom Bar (a sand bar which lends its name to a locally brewed ale) stretches across the estuary from Hawkers Cove to Daymer Bay, but it is underwater at high tide resulting in many ships meeting their doom. It is said to have been put there by a mermaid who was shot by local lad Tristram Bird, who had acquired a pistol. Bored with shooting garden birds, he walked out to Hawker's Cove hoping to find larger prey, such as a seal. Instead, he encountered a mermaid combing her tresses on a rock, and took a pot shot at her. In revenge, she blocked up the harbour entrance with a sand bar. A similar story is associated with Seaton on the south coast just east of Looe. Here a mermaid became snared in a fisherman's net and silted up the harbour in revenge.

Cornwall's best-known mermaid legend comes from the village of Zennor, on the rocky coast between St Ives and Land's End. The mermaid attended church on Sundays in order to seduce a member of the choir. Matthew Trewhella had a beautiful tenor voice which the mermaid was attracted to, and it seems Matthew's roving eye had spotted the attractive fair-haired girl in the back of the church. One fateful Sunday he slipped out as soon as the service was over to follow her home. She led him to the coast at Pendour Cove where she beckoned him into the sea and he was never seen again. Many years later, she reappeared and was seen by the captain of a ship who heard a woman's voice calling for Matthew Trewhella. The story is remembered in the church of St Senera which has a carving of a mermaid on a 500-year-old bench end in the side chapel. The bench end has been repurposed to make a narrower chair, possibly for some person of rank. Recently, experts using a technique called polynomial texture mapping discovered that the original bench end bore an abstract design, over which has been carved the mermaid figure.

The deadly Doom Bar on the Camel Estuary.

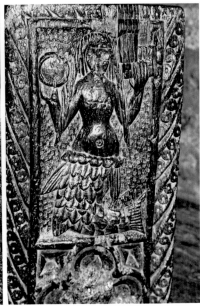

Zennor (*left*) church of St Senera; (*right*) the carved mermaid.

Betty Stogs and the Piskies

Cornish folklore, like its Celtic counterparts in other parts of the British Isles, weaves a complex web of beliefs about what are generally termed fairy folk. In Cornish lore, the principal characters are the knockers, who live underground in mines, and piskies, mainly found on the moors and coastal villages. Knockers were thought to be the origin of knocking noises heard by miners, and have an evil disposition. Piskies are mischievous and enjoy playing pranks on humans, but they can also be kind and helpful, albeit with a selfish motive. As recently as the 1950s it was still common to hear Cornish people 'laughing like a pisky' and feeling 'pisky-led', or 'pisky-laden', if they were a bit forgetful, say. Souvenir shops were stocked with brass pisky door knockers or dishes with pisky motifs, a trend which is less obvious today. A few do still specialise in pisky-themed items, such as at Polperro, which has a tradition of tales featuring a local character, Joan the Wad. She was the female equivalent of Jack o' the Lantern, 'wad' in this context meaning a torch. They offered an explanation for the strange lights which appeared over marshland at night, which we now know are caused by the emission of flammable methane from decomposing vegetable matter:

> *Jack o' the Lantern, Joan the Wad,*
> *Who tickled the maid and made her mad*
> *Light me home. The weather's bad.*

Stories of practical jokes by piskies in Polperro are typified by what happened to Robin Hicks, a local fisherman in the nineteenth century. One stormy night as he was enjoying his supper, he heard a shrill voice crying 'Robin! Robin! Your boat is adrift!' On reaching the quay he saw that his boat was still safely on its mooring and returned home to his cold meal with the sound of pisky laughter ringing in his ears.

(*left*) Cornish pisky souvenir; (*right*) Joan the Wad, Polperro.

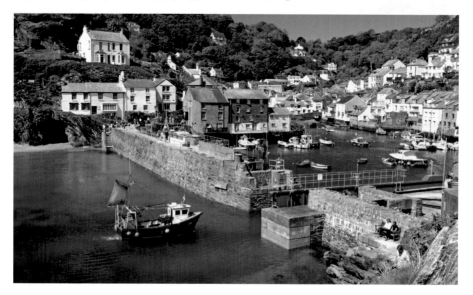

Polperro harbour.

Betty Stogs also had an encounter with piskies. She lived near St Ives in the hamlet of Towednack. Betty had a loving husband and six-month-old baby but her love of 'gadding about' meant she neglected the baby, who the neighbours observed was in need of a good wash. Betty believed that the extra layers of grime served to keep the baby warm, and continued with her social life, going out every day after her husband left for work at the mine. The baby was left with the grime and the cat for warmth, until the day Betty arrived home after dark to find both baby and cat missing and her husband distraught. An all-night search was fruitless but at dawn they found the baby wrapped in layers of cloth in a furze (gorse) bush. He was spotlessly clean, having been stolen by piskies who intended to wash him and take him away for good. However, the amount of grime was more than they bargained for and daybreak came before they finished, to Betty's good fortune. Today she has been given a new role in life promoting the brand of Cornish ale named after her. Skinners Brewery in Truro launched Betty Stogs ale in 1997, describing it as brazen, golden-hearted and more than a little fruity, just like Betty. She has been brought to life by Fred Thomas, whose appearances as his pantomime dame-style alter ego has raised over £100,000 for charity over the years.

Legends of piskies have even been exported to Australia, where the town of Kapunda near Adelaide has been celebrating them in a school holiday project during 2021. Tourism development manager Liz Heavey explained that the early settlers' folklore stories of piskies and knockers are part of Kapunda's history, as a result of Cornish miners emigrating there in the nineteenth century to work in the town's copper mines.

Fred Stephens, *aka* Betty Stogs, fundraising. (Photo: Skinners Brewery)

Above and below: Cornish piskies in Kapunda, Australia. (Photos: Liz Heavey)

Turned to Stone

Cornwall's granite moors are littered with boulders and in prehistory, many of these were used to build stone piles, or cairns, dating from perhaps 2000 BC. In addition, there are numerous standing stones, often arranged in circles or rows. Like Stonehenge, the original purpose of these constructions is lost in the mists of time, theories ranging from some kind of astronomical purpose or as calendars. Our more recent ancestors, with their puritanical Christian beliefs, came up with more fanciful ideas. One particular obsession was with Sabbath-breaking, leading to the names that these artifacts are given today. At Boleigh Farm near St Buryan in west Cornwall is a stone circle known as the Merry Maidens. There are nineteen stones with one in the centre. The belief that they were dancers literally petrified for breaking the Sabbath goes back to at least 1730. Across the road two further stones, The Pipers, were said to be petrified musicians who were accompanying the dancing. They had sped up their playing so that the dancers could finish quickly and escape their stony fate, but this only led to their collapsing with exhaustion, explaining the strange angles of some of the stones. In addition, the stones are reputedly impossible to move, and attempts have led to the beasts of burden charged with the task falling down dead. Less than 10 miles away at Tregeseal near St Just are the Dawns Mên or Dancing Stones, remains of three stone circles, with a similar legend. Between Madron and Morvah at Boskednan, in open moorland, are the Nine Maidens, once much larger having some twenty-three stones, many of which have been scattered far and wide by farmers looking for gateposts and hedging materials. There is a stone row of the same name near Winnard's Perch in a field beside the A39 between St Columb and Wadebridge.

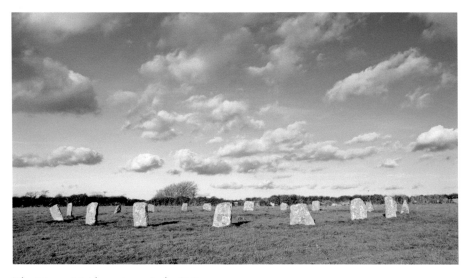

The Merry Maidens stone circle, St Buryan.

On Bodmin Moor near Minions is the most famous of Cornwall's circles, The Hurlers. Norden wrote in 1584, 'Fixed in such strange manner as those country men do in performing that pastime hurling', playing the sport on the Sabbath, of course. Just twenty years later Carew added another facet to the legend thus: 'A redoubled numbering never eveneth with the first', referring to the belief, also associated with Stonehenge, that it was impossible to count the number of stones twice and get the same answer. The Hurlers are actually three circles arranged in a line, and date from the late Neolithic period. The northern and central circles both contained between twenty-eight and thirty stones each, which have been chiselled smooth. The remaining circle is smaller. Two further stones, The Pipers, stand nearby.

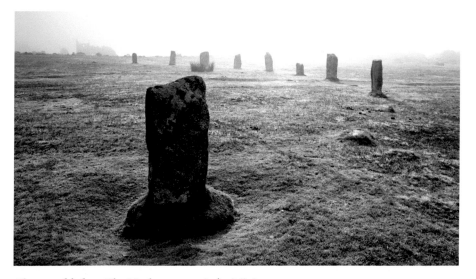

Above and below: The Hurlers stone circle, Minions.

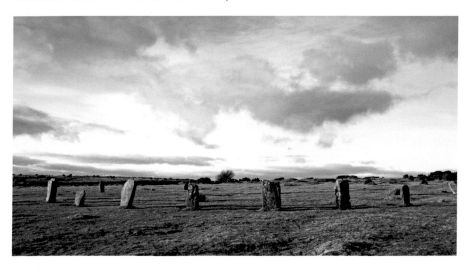

Giants

Cornwall abounds with legends of giants, indeed, one tells us that Cornwall itself was named after a fight with one of them. It took place at a time when the country of Albion was ruled by Brutus who had invaded with his Trojan army, and after whom some say the country was renamed Britain. According to Geoffrey of Monmouth, the Trojans had a wrestling champion, Corineus, who enjoyed fighting with giants, and one in particular, Gogmagog, the leader of the legendary giants of Albion. One version of the story places the fight on Plymouth Hoe. After Corineus defeated the giant by throwing him over a cliff, he was gifted the land west of the Tamar by a grateful Brutus and named it Corinea or Cornovia. In 1612, the poet Michael Drayton celebrated the victory in his epic poem *Poly Olbion*:

> *… for which the conquering Brute on Corineus brave*
> *This horn of land bestow'd and mark'd with his name*
> *Of Corin, Cornwall call'd to his immortal fame.*

Giant Bolster is associated with the mining village of St Agnes on the north coast, and as a measure of his stride, we learn that he could place one foot on the hill at Carn Brea, near Redruth, and the other on St Agnes Beacon, 6 miles distant. He was feared by the locals because of his habit of eating children. He also bullied his wife, making her carry stones up the cliff in her apron. He developed a crush on St Agnes, which was unrequited, but he continued to pester her. The gallant knight Constantine tried to rid her of the problem by challenging Bolster to a fight on the cliffs, but even he was easily defeated by the giant. Eventually she got so fed up with being stalked by a lovelorn giant that she promised Bolster she would marry him if he completed the task of filling a shaft in the cliffs with his blood. Not realising that the shaft was bottomless, the overconfident giant attempted the task with fatal results. The story explains the red stains on the cliffs at Chapel Porth, in reality a result of mining activity on this heavily mineralised part of the coast. The story is re-enacted around the village and cliffs at St Agnes over the Spring Bank Holiday every year, with giant puppets and other entertainers. Another giant who bullied his wife into carrying stones in her apron was Cormoran. He was constructing St Michael's Mount out of special white stone from several miles away, and made his wife fetch the stone in her apron. When Cormoran was taking a nap one day his exhausted wife tried to collect local stone to save her legs, but he awoke and kicked her so that she deposited the stone on the beach near the Mount, creating the causeway which today links it to the mainland.

Perhaps the most famous Cornish giant was Tregeagle, who has more recent origins. In the seventeenth century, he was the unjust land steward at Lanhydrock House, near Bodmin, extorting money from his master and tenants and murdering

Characters from the Giant Bolster pageant, St Agnes.

his wife and children. After his death his soul came into the possession of the devil and his noisy ghost was condemned to a series of Herculean tasks. He was sent to Bodmin Moor and tasked with emptying Dozmary Pool with a leaking limpet shell, encouraged in the task by the baying of a pack of demonic hounds. The pool was thought to be bottomless, but in fact is only a few feet deep. During a terrible storm one night he attempted to flee from the hounds, but they pursued him to Roche Rock where he sought sanctuary in the fifteenth-century hermitage there. However, only his head could be accommodated in the tiny chapel and his body remained exposed to the elements and his roaring continued until he was banished to Padstow. He so disturbed the locals there that he was moved on again, this time to carry bags of sand from Porthleven to Mount's Bay. A sack burst as he crossed the mouth of the River Cober near Helston, thus creating a shingle ridge, Loe Bar.

When the influence of the Celtic saints began to spread across Cornwall, the giants were concerned enough to hold a meeting on Bodmin Moor. Their leader, Uther, was challenged by St Tue, after whom St Tudy is named, to a trial of strength and skill, a stone-throwing contest. Twelve flat stones were thrown alternately by the two sides, forming a pile. When it was the turn of the saints to throw the final stone, a throng of angels seized it and deposited it on top of the pile, securing victory and banishing the giants from Cornwall. This story was told to explain the origin of the Cheesewring, a natural rock formation near the village of Minions.

Dozmary Pool, Bodmin Moor.

The hermitage, Roche Rock.

The Cheesewring, Bodmin Moor.

The Lost City of Langarrow and the Gannel Crake

The pretty village of Crantock near Newquay is named after Carantoc, the son of a Welsh chieftain. As a young man he had visited Ireland to become a disciple of St Patrick. He is said to have crossed the Celtic Sea in a coracle and eventually came ashore on the River Gannel near Newquay. Buried under the dunes south of the estuary is a legendary city called Langarrow or Langona. One of the largest in the country, as a measure of its size we are told that it had seven beautiful churches. In order to trade tin, lead and other commodities, a harbour was built using convicts from all over Britain as the workforce. They were housed in the environs of the city, separate from the main God-fearing population, but over time boundaries were eroded and life in Langarrow became increasingly immoral. The result was that, some 1,000 years ago, the city suffered divine retribution when a great storm blew up lasting for three days and which buried the city for ever beneath the newly created dunes – a kind of Cornish Sodom and Gomorrah. In the nineteenth century, Crantock church was often referred to as Langona.

A more recent story associated with the estuary is that of the Gannel Crake, a strange bloodcurdling cry heard at dawn or dusk which the legend attributes to a troubled spirit, possibly of a long-lost sailor. Accounts go back 200 years and a nineteenth-century witness describes it thus: 'it was like nothing on earth, like a thousand voices pent up in misery, with one long wail dying away in the distance'. He and his brother had been loading a cart with seaweed when they heard the cry, which seemed to come from directly overhead. Their horses bolted across the beach on hearing the sound.

Dunes beside the Gannel, Crantock.

2

Saints and Their Wells

St Piran

Piran is one of three saints who can lay claim to being Cornwall's patron saint, the others being St Petroc and St Michael. Today, Piran has been adopted almost universally. Born in the fifth century, he grew up in Wales, where he attended a school in the monastery of St Cadog. One story says that he spent fifteen years in Rome before travelling to Ireland where he lived in various religious communities before establishing his own at Clonmacnoise. Reminiscent of St Francis, his first converts in Ireland were said to be bears, foxes, badgers and wolves and like many religious men living in Ireland in those days, he travelled to take Christianity to other Celtic nations, including Brittany and Cornwall.

Piran first arrived in Cornwall as an old man; one legend says he lived to over 200. This was in the sixth century when, having fallen foul of the King of Leinster, he had been thrown off a cliff with a granite millstone around his neck. The stone miraculously floated and carried him to the north Cornish coast, coming ashore at what is now named Perranporth (Piran's beach) in his honour. Among the sand dunes he built a cell, from where he preached and, it is said, performed many miracles. He travelled all over Cornwall founding churches, from Perranuthno and Perranarworthal in the west of the county, to Tintagel in the north, where there is a well dedicated to him.

The connection with tin arose from an incident one winter's night when St Piran had stoked up a hearty fire to warm himself. A black stone which he had used to form part of the hearth suddenly cracked in the heat and molten white metal began to flow out. The stone was cassiterite, and St Piran had discovered tin. This has earned him a place in the heart of tin miners, and, legend says, was the birth of the Cornish flag, a white cross on a black background, the white cross representing the tin flowing from the black ore. In fact, the Romans had previously found and smelted tin in Cornwall, but after their departure the know-how had been lost. Another legend tells of the saint's death at the age of 206, apparently. He enjoyed a tipple, and following a drinking session one night he fell down a well, from which derives the Cornish expression 'as drunk as a Perraner'. Following his death, an oratory was built in the dunes, which later in the tenth century became buried in shifting sands and had to be abandoned. A new church was then built some distance away, next to an ancient Celtic cross. Here the saint's head was kept in a casket, together with other relics, which were regularly paraded around Cornwall. The church became a popular stopping point for pilgrims on their way to Spain in the fourteenth century, but eventually was also engulfed by sand. In 1804, much of the fabric, including the tower, was

used to build another church at nearby Perranzabuloe, (St Piran in the Sands). In 1835, the oratory, one of the oldest Christian sites in England, was uncovered and later in 1910 it was encased in a concrete shell for protection. Problems with flooding and vandalism eventually led to the decision to rebury it, but in 2014 it was uncovered again, although with its protective shell of concrete blocks it resembles a building site. St Piran's day is celebrated in Cornwall, and Cornish communities worldwide, on 5 March, with processions led by a Cornish piper held in a number of towns. On the Sunday following, the pilgrimage to the saint's oratory and cross takes place across the dunes at Perran Sands. At the oratory site, a play is performed depicting events from the saint's life.

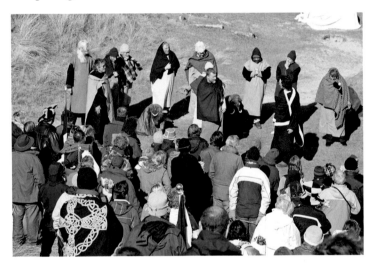

Scenes from the
St Piran pilgrimage,
Perran Sands.

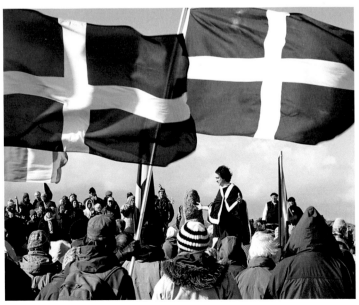

St Piran even has a species of hermit crab named after him! In 2016, the BBC's *Springwatch* programme ran a competition to find a common name for the crab which was returning to Cornwall's shores after thirty years of absence – only on rare occasions are sea currents favourable for the tiny crab larvae to make it from Brittany across to Cornwall. There is a parallel with St Piran, a hermit who survived being thrown in the sea, turning up in Cornwall to find a home.

St Petroc

Born in Wales during the sixth century, Petroc studied in Ireland and like Piran travelled to Cornwall, making landfall on the north coast where he founded a monastery near Padstow, a contraction of Petrockstow. He travelled widely across Devon and Cornwall, and many churches in the two counties bear his dedication. He also undertook pilgrimages to Rome, Jerusalem and as far afield as India, where he is supposed to have stayed for seven years. Returning to Cornwall, he killed a mighty serpent, removed a splinter from the eye of a dragon, and from his cell on Bodmin Moor protected a hunted deer from certain death at the hands of Constantine, whom he converted to Christianity for good measure. In AD 530 he founded a monastery at Bodmin, where the fifteenth century parish church, the largest in Cornwall, is dedicated to him. After his death in AD 564, his bones, originally kept at Padstow, were moved to the priory in Bodmin which was considered safer. However, in 1177 one of the canons was bribed to smuggle the bones across the channel to the abbey of St Meen in Brittany. This caused a diplomatic incident with Henry II intervening and sending an emissary to Brittany to negotiate the recovery of the relics. By way of compensation the Bretons

St Petroc's Church, Bodmin.

presented him with a fine ivory and gold casket to contain them. The casket was returned to Bodmin via Winchester where it was blessed by Henry, and it has by some miracle survived to the present day. A genuine piece of Norman craftsmanship, the reliquary is exhibited in a glass case in St Petroc's Church, but no longer contains the relics. It has been lost twice since, the first time during the Reformation where it was hidden in a secret room for safe keeping, only being discovered again in 1831. In 1994, the casket disappeared again after the church suffered a break-in. A police investigation plus publicity in the national press led to the stolen casket eventually being found in a field in Yorkshire, although how it got there has never been explained. After returning to Bodmin, it is now exhibited in a more secure glass case.

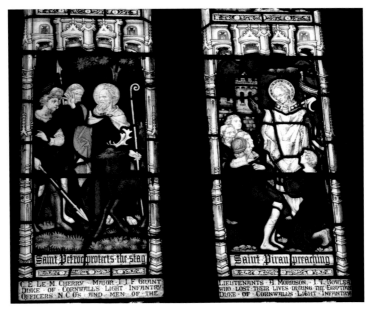

St Petroc and St Piran depicted in stained glass at St Petroc's, Bodmin.

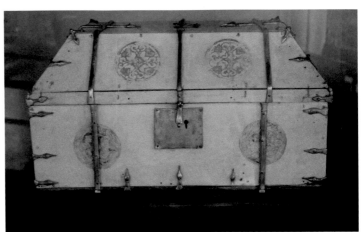

Thirteenth-century ivory reliquary, St Petroc's, Bodmin.

St Neot

St Neot is a pretty village on the southern rim of Bodmin Moor centred around a magnificent fifteenth-century church. Dedicated to St Anietus, it houses one of the finest collections of stained-glass windows in the country. Little is known of St Neot himself, and historians disagree over whether he and Anietus were the same person. One source says that he was the son of a Saxon king, related to Alfred the Great, and it is from a book about St Neot that we get the famous story of King Alfred burning the cakes. In this version of the story, he decided to forego worldly power to become a monk at Glastonbury, afterwards moving to Bodmin Moor. However, he still retained his political contacts, acting as an advisor to Alfred, who is said to have visited him in Cornwall. A wooden tablet in the church tells us in rhyme that:

> *His father was a Saxon king, St Dunstan was his teacher,*
> *In famous Oxford he was eke the first professed preacher.*

A holy well dedicated to him is still to be found along a track beside the River Loveny, a few hundred yards from the church. The well has been covered with a cross as long ago as the eighteenth century and bears the inscription that it was restored in 1852, although the guidebooks say 1862. This was financed by the vicar, Revd Henry Grylls, who also wrote a guide to the windows. Even today strips of cloth hang from the branches nearby as votive offerings. Like wells in the Peak District, it is dressed as part of the flower festival held in the church. Known

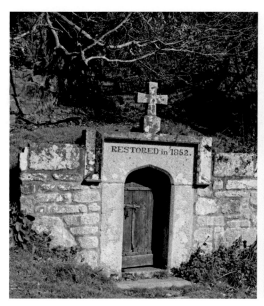 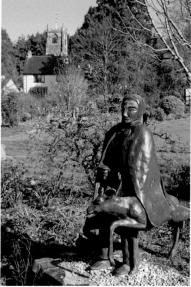

St Neot (*left*) holy well; (*right*) bronze of the saint by Peter King.

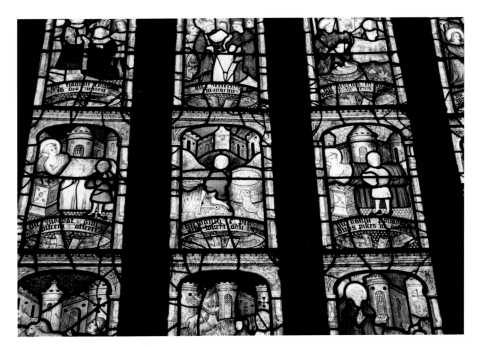

The St Neot window.

as the Pygmy Saint, he was reputed to be only 4 feet tall, and had a daily ritual of standing up to his neck in the well water reciting all 150 Psalms, which must have taken some time. One day he found three fish swimming in the well, from which sprang the story which is told in one of the stained-glass windows in the church. It carries a modern conservation message. An angel informed him that to maintain the supply of fish, he could eat only one fish a day. One day the saint was ill and his servant caught two fish and cooked them, boiling one and grilling the other. Horrified, he instructed the servant to return the cooked fish to the well, where they miraculously returned to life. He was good with birds too; an earthwork near the village is known as the Crowpound, where the saint confined all the crows in the parish on Sundays so that farmers could attend church instead of staying at home to scare the birds away from their crops.

St Levan

Another fishing saint, Levan, lived near Porthcurno in west Cornwall where the ruins of his well overlook Porth Chapel Cove near the Minack Theatre. He went fishing daily, like St Neot catching and eating one fish a day, including on the Sabbath. One day he caught three bream and cooked them for his sister, St Breaca, patron saint of Breage. She fed them to her hungry family, but omitted to remove the bones and the children choked on them – hence bream were referred to as 'choke children' or 'chuck cheelds' in west Cornwall until well into the twentieth century. Two fish are carved on a bench end in the church. His habit of fishing on

the Sabbath led to a rebuke from his vegetarian (and sanctimonious) neighbour Joanna who nonetheless saw no sin in gathering herbs on Sundays. Levan believed that fishing on the Sabbath was no worse than gardening, and thereafter decreed that any child born in the parish and named Joanna would grow up as stupid as he believed she was. In the 1960s a patch of land near the church was still known as Joanna's Garden.

Porth Chapel Cove, St Levan.

The church of St Levan.

St Keyne's Well

St Keyne was one of fifteen daughters of Braglan, a sixth-century Welsh prince. The legend says that on her deathbed she imparted magical properties to the water from the well, which lies in the Looe valley half a mile away from the romantically named St Keyne Wishing Well Halt on the railway line between Liskeard and Looe. It is sheltered under trees in a mossy dell and nearby branches are hung with scraps of cloth, votive offerings showing that old superstitions still have power in modern-day Cornwall. The legend says that the first partner of a newly married couple to drink from the well after the wedding will have the upper hand in the relationship. During the nineteenth century, the story became popularised by the poet Robert Southey, and newly married couples would travel by train to the halt and then race up the hill to the well. The husband in Southey's poem missed a trick!

> *I hasten'd as soon as the wedding was o'er,*
> *And left my good wife in the porch,*
> *But i' faith she had been wiser than I,*
> *For she took a bottle to church.*

St Keyne's Wishing Well.

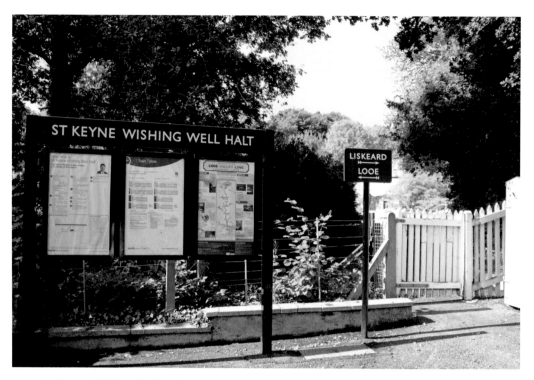

St Keyne's Wishing Well Halt.

3

Tales of Fishing, Smuggling and Mining

Mother Ivey's Curse

On the north coast between Trevose Head and Harlyn Bay is Mother Ivey's Bay, named after a matriarch who lived in the sixteenth century and was said to be a white witch. Her powers were put to use during a period of famine which was causing hardship in the locality. Between Harlyn Bay and Mother Ivey's Bay was a pilchard packing factory owned by the Hellyer family. They exported salted pilchards to the Mediterranean, and one day a cargo of fish was returned from Italy unsold, a little past their best perhaps, but perfectly edible. When the starving villagers asked the Hellyers if they could have the pilchards, their request was refused and instead the fish were ploughed into a nearby field as fertiliser. Mother Ivey was incensed and cursed the field, condemning anyone attempting to plough it to suffer a death in their family. The Hellyers ignored the curse but soon after working the soil their eldest son was thrown from his horse and killed. The field remained untouched until the Second World War when, we are told, the Home

Mother Ivey's Bay.

The pilchard factory with (*inset*) its inscription 'Lucri dulcis odor'.

Guard dug some defensive trenches, again with fatal consequences to the family's eldest son. Then in 1970, a metal detectorist suffered a fatal heart attack just days after attempting to dig in the same location, and more recently the foreman from a utility company died a day after laying water pipes in the field.

The pilchard packing factory still stands beside the coast path just south of Harlyn Bay. It has now been converted into holiday accommodation, but the Hellyer family motto can still be read carved on the lintel above a window. It reads 'Lucri dulcis odor', translated as 'profit smells sweet', a fitting epitaph perhaps for a fish processing plant.

Tom Bawcock

Another famine tale dating from the sixteenth century comes from the fishing village of Mousehole (pronounced Mowzel), near Penzance. A succession of winter storms during December prevented fishermen from getting out of the harbour, and as Christmas approached, so did the threat of starvation. On 23 December, the oldest and most experienced fisherman, Tom Bawcock, decided to brave the tumultuous seas and ventured out, miraculously returning to the relieved villagers with a boatload of seven different species of fish. In order to celebrate, they baked the whole catch into an enormous pie, leaving the heads and tails poking out in order to prove that the pie did indeed contain fish. Every 23 December, Mousehole celebrates Tom Bawcock's Eve by baking this local dish, called Stargazy Pie, which is served at the Ship Inn overlooking the harbour. There is also a parade headed by Tom Bawcock, who leads the procession carrying the pie for all to see. The associated tale of the Mousehole cat tells of Tom's cat

Mouzer, who, despite his name, lived on a diet of fresh fish, and who is said to have accompanied Tom on his fishing trip that night. Today the story is celebrated by Mousehole's famous Christmas lights display, which began in 1963, and which attracts thousands of tourists during the festive season. There is a more sobering side to the story though. On the evening of 19 December every year, the 10,000 bulbs are dimmed in memory of sixteen seafarers who died on that night in 1981 when the brand-new cargo ship MV *Union Star* lost engine power and drifted onto rocks off Boscawen Cove in hurricane-force winds. Attempts to rescue the crew by helicopter failed, and at 8 p.m. the Penlee Lifeboat, the *Solomon Browne*, was launched. She was crewed by eight volunteers from Mousehole, and after surviving 60-foot-high seas, managed to get alongside the stricken vessel and take off four of the crew. Shortly afterwards radio contact with the *Solomon Browne* was lost along with the lifeboat and her crew. The attempted rescue was later described by the pilot of the rescue helicopter still hovering overhead as 'The greatest act of courage that I have ever seen, and am ever likely to see, ... they were truly the bravest eight men I've ever seen, who were also totally dedicated to upholding the highest standards of the RNLI.' Within twenty-four hours enough volunteers had come forward to form a new lifeboat crew, and an appeal was started to raise £3 m for a new and faster lifeboat with the lifeboat station relocated to nearby Newlyn. A memorial was erected to the crew of the *Solomon Browne* at the old lifeboat house in Mousehole.

Mousehole Christmas lights. (Photo: Mike Ellis)

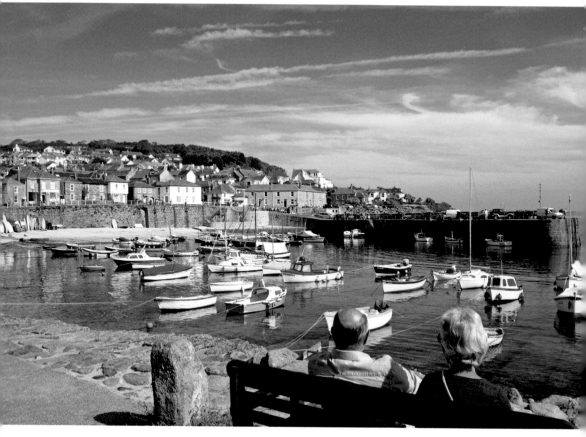

Mousehole harbour.

The Carters of Prussia Cove

Brothers John and Harry Carter were two of the most famous Cornish smugglers of the late eighteenth century. Born in 1738, John, the eldest, was nicknamed the King of Prussia, one of his childhood heroes being Frederick the Great, and the cove where his smuggling operation was based became known as Prussia Cove. Lying on the south coast close to Mount's Bay and well hidden from view, it was an ideal smuggling base for an overnight voyage from the French coast, if you had a fast boat. The Carters had two, a cutter armed with nineteen guns, and a lugger with twenty guns, each with thirty crewmen and each backed up by a smaller boat to ferry goods onto shore. They had a secret tunnel to convey the contraband to their cellars ashore. We know a lot about their adventures from Harry's autobiography, from which we learn that both Harry and John held strong religious convictions and were converts to Methodism, even forbidding the crew from swearing during their smuggling voyages. Harry's smuggling memoirs were actually first published in a Methodist journal. They were known for fair dealing, and one story relates to a cargo of contraband they had stored at

the cove which was raided by the customs officers while the brothers were away. John successfully organised a night-time raid to retrieve it from the customs house at Penzance. The customs men declared that they knew who had carried out the raid because only the Carters' goods were missing.

Sometimes the establishment could make use of the Carters' swashbuckling skills, such as in 1782 when a French privateer, the *Black Prince*, was harassing shipping in the Bristol Channel. The Carters received a request from John Knill, collector of customs at St Ives, to attack the vessel and put her out of action. They took two of their vessels and engaged the *Black Prince*, eventually sinking her just off Padstow, rescuing sixteen of the thirty-one men aboard, the French captain having abandoned ship.

In 1788, Harry was almost killed unloading contraband up the coast at Cawsand. He had brought the lugger close inshore and saw two small boats coming out to meet them, which he assumed were taking goods ashore. Too late the crew realised that the boats were actually from a man of war and full of excise men, and a fierce battle ensued, the excise men boarding the lugger and attacking the smugglers with muskets and broadswords. Harry was beaten unconscious and left for dead. Somehow, he managed to lower himself into the water and crawl ashore, where he spent the next three months in hiding with a price of £300 on his head. He was secretly moved to west Cornwall, hiding at Acton Castle, a stately home which had only just been built for botanist John Stackhouse, who was studying marine algae at Stackhouse Cove nearby. Located just to the west of Prussia Cove, it was also a convenient base for John Carter, who took advantage of its infrequent occupation by Stackhouse and stored contraband in the castle, even constructing a tunnel to the coast at Stackhouse Cove. Harry Carter eventually retired from smuggling to become a Methodist preacher until his death in 1809. The date of John's death is unknown.

Prussia Cove.

Cornwall's Worst Mining Disasters

The mining boom of the nineteenth and twentieth centuries was a time of rapid development in mining technology, led by engineers such as Richard Trevithick. Hard rock mining so far underground was fraught with dangers, from flooding, accidents with explosives, to boiler explosions and failures of steam-powered lifts.

Cornwall's worst mining disaster took place at East Wheal Rose near Newquay. Unusually for Cornwall, this was a lead mine employing some 1,200 men, women and children at the time. The mine had at least twenty shafts in operation, extending some 900 feet below the surface. During the morning of 9 July 1846, the sunny weather gave way to ominous storm clouds which broke during the afternoon with heavy rain and a freak thunderstorm lasting over an hour. Within a few minutes, run-off from the surrounding land flooded the site, and the Lappa Valley stream which normally drained the area was overwhelmed. Despite attempts to protect the shafts, water quickly burst through the defences and cascaded down to the tunnels below. There were 200 men underground at the time and they were soon engulfed in water. In a selfless act of bravery timber-man Samuel Bastion lay face-down across a manhole, diverting the flow of water and saving the lives of eighteen men in the tunnel below. In all thirty-nine lives were lost that afternoon. Since the 1970s the site has been the home of a tourist attraction, the Lappa Valley Railway, served by narrow-gauge steam trains. The engine house is the largest of all the county's remaining examples.

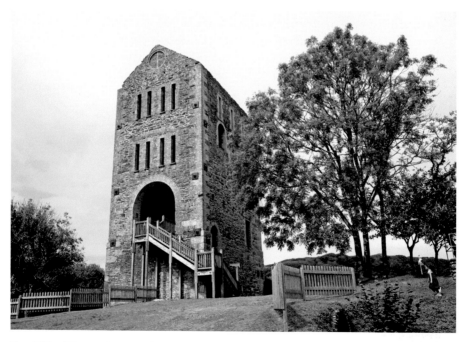

East Wheal Rose mine, Newlyn East.

Another flooding accident occurred at Wheal Owles on the west Cornwall coast at Botallack, on 10 January 1893. Some forty men and boys were underground at the time, while 400 feet below the surface miners prepared to explode a charge, unaware that they were using inaccurate plans. As a result, the explosion let in water from a flooded part of the mine, which cascaded into the tunnels. In the race against time to evacuate the mine, nineteen men and one boy lost their lives. The error was the result of the surveyor failing to correct his plans for variations in magnetic north, and he was devastated on learning of his fatal mistake. Today the ruined Wheal Owles engine house has a new role as Wheal Leisure in the BBC production of Poldark.

One of the worst lift accidents happened not far from Wheal Owles at Levant, on 20 October 1919. The miners travelled to and from the surface in a 'man engine', a steam-powered lift which was first installed in 1857, a great improvement on the ladders used previously. The device consisted of a reciprocating rod driven by the steam engine, attached to which were 150 wooden platforms spaced 12 feet apart, which aligned with a series of fixed platforms used to access the various levels. By stepping on and off these platforms as the rod paused at the end of each stroke, men could ascend or descend the shaft 12 feet at a time, taking almost 30 minutes to reach the lowest tunnels, 1,600 feet underground and extending a mile under the sea. Around 3 p.m. on that October day, a group of 120 miners were travelling up the shaft after their day's work when a connecting rod failed, sending the lift laden with men crashing down the shaft, destroying many of the platforms in the process. As a result, thirty-one miners died, and rescuers worked for five days to get all the bodies out of the shaft.

Wheal Owles engine house.

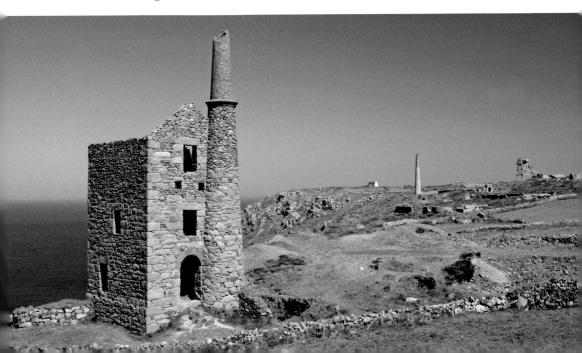

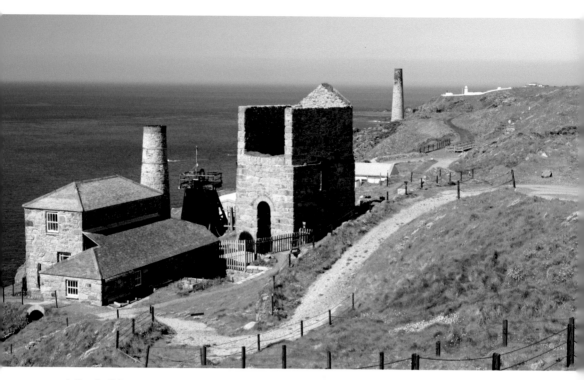

Mine buildings, Levant.

4
Most Haunted

Pengersick Castle

Overlooking Praa Sands east of Marazion, Pengersick Castle dates from the sixteenth century and was built on a site occupied by Henry de Pengersick for some 200 years before the family was wiped out by the plague. The fortified tower house we see today was built in 1510 by William Worth but by 1520 it had passed into the ownership of John Milliton, who in 1527 looted the *St Anthony*, a Portuguese ship wrecked off Gunwalloe near Mullion. The ship was laden with treasure said to belong to the King of Portugal, and Milliton's haul was rumoured to be worth £18,000. Guns and musical instruments from the looted ship are known to have found their way to the castle, which was extended by Milliton using his new-found wealth. He constructed a granite staircase which runs up to the tower where holes were cut to enable boiling oil to be poured onto invaders: these were lawless times and many raids by foreign privateers took place on this coast. By 1640 though, ownership had been divided between Milliton's six daughters and the castle fell into decay, eventually ending up as part of the adjoining Godolphin family estate.

Pengersick Castle.

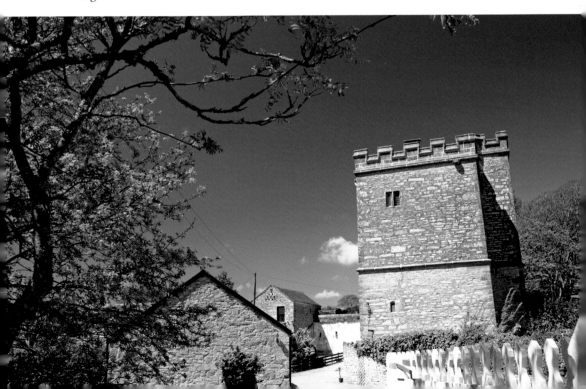

Today the castle has the reputation of being one of the most haunted places in the country, and has been featured on numerous TV programmes. It is said to be haunted by the ghost of John Milliton, who had attempted to poison his wife but who had the tables turned on him when she switched the drinks. There is also the ghost of Engrina Pengersick, wife of Henry, an apparition who appears to be writhing in agony, a young girl in a white dress who fell from the roof, Alexander the cat and a demon dog with fiery red eyes. Many of these tales are likely to have their origin in stories spread by smugglers who needed to keep prying eyes away from the building at night.

The Botathan Ghost

This tale comes to us through no less a literary figure than Daniel Defoe, who visited Launceston in 1705 and subsequently included an account in a pamphlet entitled *Mr Campbell's Pacquet, for the Entertainment of Gentlemen and Ladies* published in 1720 and edited by William Bond. The story as published by Defoe purports to be an account by Revd Dr John Ruddle bearing the title *A Remarkable Passage of an Apparition* which dates from 1665. Since it appeared, various authors have tried to claim that the story was an invention by Defoe, but Sabine Baring Gould among others believed that it was a straightforward first-hand account by Revd Ruddle.

In June 1665 Ruddle, the vicar of St Mary Magdalene, Launceston, officiated at a funeral in the village of South Petherwin. Afterwards he was invited to dine at a nearby house named Botathan by an elderly gentleman named Bligh. Also invited was a priest from a neighbouring parish, Revd Samuel Williams, who told Ruddle of the motive behind the invitation. It transpired that the family's youngest son, previously happy and outgoing, had become frightened and was refusing to go to school as a result of what he believed to be a ghost which he always met while crossing a field on his daily walk to school. The parents were suspicious of the boy's motives, but Ruddle, who was headmaster of the school in Launceston, talked with the boy and became convinced of his truthfulness. The boy told Ruddle he believed the ghost to be that of a neighbour, Dorothy Dingley, who had died eight years earlier. She had passed him on the footpath, walking in the opposite direction, both morning and evening every day for well over a year. He had tried offering a greeting but never received a reply. He eventually altered his route to avoid the field, but she also changed her route, always meeting him in the same narrow lane. This caused the boy increasing anxiety, so he had confided in his parents, who in turns laughed at or chided him, leading to his refusal to go to school at all.

The following morning at 5 a.m., Ruddle accompanied the boy on his walk to school, and had only just begun crossing the field when they saw the woman approaching them. Ruddle was strangely affected and although resolved to converse found himself unable to; neither could he look over his shoulder after the apparition had passed by. Convinced of the boy's truthfulness, he revisited

the field alone a week or two later, when he again encountered the apparition. He then invited the boy and his parents to accompany him when they all four saw the apparition. The boy's parents confirmed that the woman's features resembled those of the late Dorothy Dingley and Ruddle observed that the spectral figure did not appear to move by walking, but rather glided along. On reaching the stile at the end of the field, she disappeared completely. The following day Ruddle met her again and this time engaged the woman in conversation, although to begin with her voice was barely audible and her words unintelligible. He repeated the process that evening after sunset, intending to exorcise the spirit, and after a conversation lasting some fifteen minutes, he declared that the figure would never again appear 'to any man's disturbance'.

The story fascinated later writers, who conjectured that Dorothy Dingley had some grudge against the Bligh family, coming back to take vengeance on them by appearing to their youngest child. A popular suggestion was that she had an affair with his eldest brother. In 2018 there were reports in the local newspapers that the occupants of Botathan House had experienced ghostly goings on including the lights and kettle switching on and off seemingly at random, and previously a four-year-old girl staying there had spoken of being put back to bed by a strange woman when she awoke in the night. Was the spirit of Dorothy Dingley still at work?

South Petherwin and the church of St Paternus.

Crime and Punishment

Red Post

Along our highways and byways, crossroads were often used as places of execution. The placing of a gallows at a crossroads allowed swift and lethal punishment to be administered for crimes committed nearby and the remains of a corpse hanging by the roadside was a reminder to any would-be miscreants to think again. A relic of this practice still survives, namely the painting of certain signposts (properly called fingerposts) red. There are several red posts in existence, particularly in Dorset, where there are four. There is also one in north Cornwall, beside the A3072 near the village of Stratton, at a crossroads that has been known as Red Post since at least 1817. It stands opposite the Red Post Inn, which has been in existence since the Abbot of Hartland established an inn here in the ninth century 'to feed and water weary travellers passing this way'. The present buildings date from 1531, when the thatched cottage was built. In 1643, it was used by Roundhead soldiers before engaging with Royalist troops at Stratton. The current inn is now housed in the adjoining stable block.

In the eighteenth century, the thatched inn was used by smugglers to stash contraband, and even boasted a secret room accessed by a false chimney to

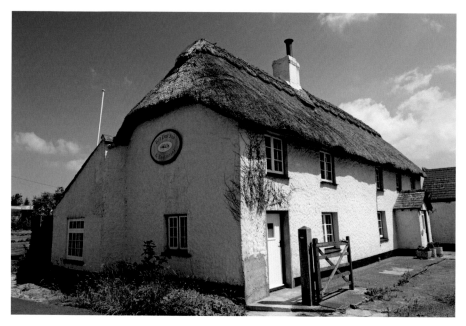

The old Red Post Inn.

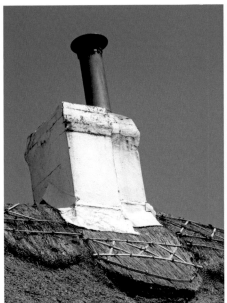

(*left*) the false chimney; (*right*) red-painted signpost.

serve as a hiding place from the excise men. It is known that frequent executions of smugglers took place at the crossroads, and the last hanging here was of a sheep stealer in the mid-nineteenth century. The signpost at the crossroads was traditionally painted red and it carried a preservation order. It was last repainted in 2010 when a missing arm was replaced. Sadly, it fell victim to thieves itself, when one night in April 2021 all four arms were stolen. The good news is that following a crowdfunding campaign enough money was raised for a local forge to recast new arms and the red post again stands proudly at the crossroads.

The Windmill Gang

On the subject of sheep stealing, in the nineteenth century a notorious gang operated out of a disused windmill near the hamlet of Mount Hermon on the flat expanse of the Lizard. The mill was built of local serpentine with walls 4 feet thick, constructed without mortar. Its existence was well established in the seventeenth century and in 1745, a local yeoman, Richard Felly, is recorded as taking out a fourteen-year lease at an annual rent of 30 shillings. In the late eighteenth century, it seems that the building was repaired: the initials 'BH 1790' are carved on two stones near the doorway. By 1840 it was no longer being used as a windmill and served as a farm building. During this period, it was the base for a gang of sheep stealers who butchered carcasses at the mill before smuggling them out via the coast at a point later known as Sheep Stealer's Cove. A plot near the mill is known as Oliver Tucker's Grave – the unfortunate Mr Tucker had been brave enough to give evidence against the gang, with fatal consequences. Eventually, in 1829, the

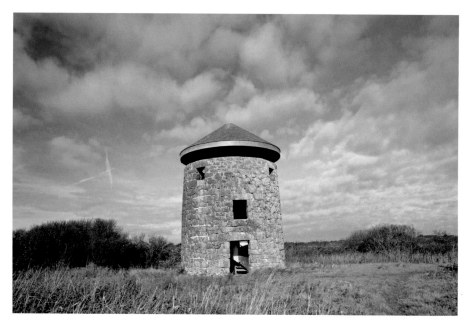

The Lizard windmill.

theft of four rams led to the arrest of the two gang leaders, one of them a butcher. With such a gruesome history, it is not surprising to hear that some still believe the mill is haunted, including the farmer who tried to use it as a cattle shelter but found that the animals refused to enter the building! Since 2001 it has been part of Windmill Farm National Nature Reserve, jointly run by the Cornwall Wildlife Trust and Cornwall Birdwatching and Preservation Society. The tower has been renovated to provide a viewing platform with an elevated conical cedar-tiled cap.

Will Tinney

We have already heard of the lost city of Langarrow near the village of Crantock across the estuary of the River Gannel from Newquay. The church is dedicated to St Carantoc, and contains some fine twentieth-century woodcarving by Miss Rashleigh Pinwell. There is also a carving in stone of St Carantoc himself, by Nathaniel Hitch, who was responsible for much of the stonework in Truro cathedral. Around the back under a little roofed shelter is a carving commissioned in 1915 from Davey and Bushell of Bristol. Unusually for a church, it depicts a sinner of the nineteenth century, Will Tinney. He is recorded as being the last man to sit in the village stocks, and we see him with his bare feet padlocked, a rather well-fed figure glaring at us with folded arms, wearing a cocked hat with an enormous feather. On the panels on either side his story is told as taken down from an eyewitness in 1896 by the vicar, George Metford Parsons. We learn that Tinney was the son of a local smuggler and in 1817 was convicted of robbery with violence, his victim being a local widow. He was locked in the stocks which

were kept in the tower. It seems he was not secured properly (in the carving the padlock is firmly in place) and in due course appeared at the top of the tower, and using the bell rope he had cut from the tenor bell, lowered himself to the nave roof and thence to the ground. He made off in the direction of the sea never to be seen again, watched sympathetically, we are told, by a group of village worthies. Among them must have been ten-year-old Richard Chegwidden, who related the tale to the vicar seventy-nine years later. Tinney's epitaph, carved beneath his bare feet, is taken from one of Kipling's Barrack Room Ballads:

I paid my price for finding out
Nor ever grudged the price I paid,
I sat in clink without my boots
Admiring how the world was made.

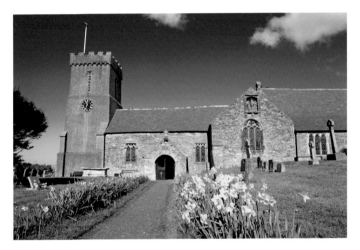

The church of
St Carantoc,
Crantock.

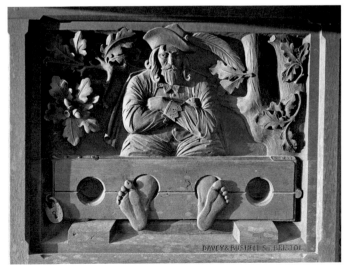

Carving of Will
Tinney, Crantock.
(With permission of
St Carantoc PCC)

Leek Seed Chapel

Just outside St Austell is the village of St Blazey Gate, which has a Methodist chapel with the unusual name of Leek Seed. The origin of the name goes back to the days before the chapel was built in 1824, when funds were being raised by an enthusiastic convert to Methodism, William Stephens. He was known as the 'Old Gardener', and worked at nearby Tregrehan House, home of the Carlyon family. Born on Dartmoor in 1742, his life as a young man was an eventful one. In 1771, he was kidnapped by a press gang while on a trip to London with his clergyman employer. He was shipped to the East Indies to join the army but his military adventures in India ended after he contracted a tropical illness and was discharged as unfit for service. Returning home, he married and eventually settled in St Blazey with his wife.

In 1786, he was converted to the new non-conformist brand of Christianity then sweeping the county. Fired by the desire to save souls, he became a local preacher, with his growing congregation meeting in an old barn. He had begun to collect funds to build a chapel, and the information that he was keeping the money in his cottage reached the ears of three young students recently down from Oxford University and who were strongly opposed to the new religion. They hatched a plot to rob the old gardener of his money. It seems that this was intended as a student prank, but somehow their intentions became known to Stephens, who was ready for them on the night they broke into his cottage. They were surprised to

Formal gardens, Tregrehan.

find him sitting by his bed, wearing his night attire, topped off by a red nightcap. Beside him on the table was an open Bible and next to it an enormous pile of what looked like gunpowder, enough to blow up a castle, illuminated by a guttering candle. The lads were horrified to see that Stephens was holding a flint, apparently about to strike a spark over the powder. Stephens invited them to join him in prayer and repent of their sins, adding that, if they did not, there would be no tomorrow for any of them. Terrified, the young men offered him the contents of their purses, for it seems they were well off. Stephens wasn't ready to let them off the hook just yet, inviting them to join him in a long-winded prayer followed by a rendition of the one hundredth psalm. Then, as the three took to their heels and fled into the darkness, he counted the money in their purses and realised he now had more than enough money to build his house of God.

At the next meeting in the barn, he recounted the tale to his congregation, which included the three robbers who had sneaked in unseen at the back to hear his account of their ordeal. They were not expecting to hear the punchline of the story though, as Stephens explained that the pile of gunpowder that had struck such dread in their hearts was actually his next year's stock of leek seeds! He did not live to see his chapel built however, and some measure of the respect in which he was held can be gained from the 2,500 people who attended his funeral service in December 1822. The imposing building that stands today is largely the original structure built using William Stephens' funds. A porch was added in 1904, together with new windows and some internal refurbishment, and in 1924 the original Sunday school was replaced. William Stephens' tomb of Cornish granite stands just beside the porch to remind all who enter of the man whose actions led to this uniquely named place of worship.

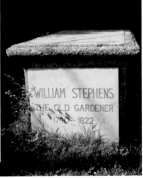

Leek Seed chapel and (*inset*) the tomb of William Stephens.

The Murder of Nevell Norway

Nevell Norway was born in 1801 at Egloshayle, just outside Wadebridge. He was the grandfather of novelist Neville Shute, and he became a successful shipping merchant dealing in timber, with a reputation as a philanthropist. On 8 February 1840, he rode to market in Bodmin, some 9 miles distant. At the market he was spotted by William Lightfoot and his brother James, who observed that Norway's purse was full of gold and silver coins. Norway did not return home until around 10 p.m. that evening, beginning his journey back to Wadebridge with a companion, the two men parting company after around 3 miles, leaving Norway to ride home alone. He never arrived, and two local farmers found his riderless horse on the road later that night. They recognised it and fetched one of Norway's servants from his home, and later that night the body of Mr Norway was found beside a stream at Sladesbridge, beside the River Camel. A doctor ascertained that the victim had been hit repeatedly about the head with a blunt instrument, and the trail of blood leading away from the body led him to conclude that the attack had happened across the road and that the body had been dragged into the stream. Footprints in the mud suggested there had been more than one attacker, and a broken hammer from a pistol was found a short distance from the body. A detective from London, Charles Jackson, was sent for, whose enquiries led him to interview a local shoemaker. He revealed that he had seen the Lightfoot brothers loitering in the vicinity earlier that evening. James Lightfoot's neighbour told Jackson

Sladesbridge.

that he had heard Lightfoot come home at a late hour, and this was followed by a furious row with his wife. A search of Lightfoot's cottage found the pistol and some ammunition hidden behind a ceiling beam. Lightfoot was arrested and implicated his brother, William, who was also interrogated. He placed the blame squarely on James's shoulders, recounting that it was James who had attacked Mr Norway, attempting to fire the pistol twice. The broken hammer meant that no shots were actually fired, so instead James battered his victim to death with the butt of his weapon. He watched James then drag the body across the road and into the stream, and the two men ran home with the stolen purse. Meanwhile, confronted with the evidence, James, imprisoned in Bodmin's notorious gaol, attempted to shift the blame onto William, who eventually confessed that he had lied in his earlier statement. The two men had hatched the plot to attack the rector, Revd Molesworth, but when they spotted Norway's purse full of money at the market, changed their plans and ambushed him instead. To add insult to injury, one of them was wearing a coat that the kindly Norway had given to him a few weeks earlier. The brothers were tried and found guilty, and sentenced to hang at Bodmin. This gruesome public event took place on 13 April 1840 and it was reported that 10,000 people came to watch, many of them on special trains laid on by the Bodmin and Wadebridge Railway, which had only recently opened. A collection held for Norway's

Nevell Norway's gravestone, Egloshayle.

wife and six children, who were left in financial difficulties, raised £3,500, an astonishing sum at the time, and is recorded on Norway's memorial stone in St Petroc's churchyard at Egloshayle.

What makes this story most remarkable is what was revealed sometime afterwards. Nevell Norway's brother Edmund was chief officer on the SS *Orient*, somewhere off St Helena at the time of the murder. The morning after the murder, Edmund told a fellow officer that he had dreamt that his brother in Cornwall had been murdered. He described the circumstances exactly: on the road between Bodmin and Wadebridge, by two men, one of whom fired a pistol twice, but which made no sound. They then struck him with the butt of the weapon and dragged his body across the road into a stream. One thing bothered him though: he knew the road very well, but the cottage he had seen in his dream was on the wrong side of the road from where he remembered it to be. He was unaware that the course of the road through the village had recently been altered. Edmund recorded these details in the ship's log, and one can only imagine how he reacted when he landed back in England six months later.

Tales of the Sea

Morgawr

Cornish for sea monster, this Cornish version of the Loch Ness Monster has been sighted around the south coast of the county for 150 years. The first detailed sighting in April 1876 was reported by the *Royal Cornwall Gazette*. Fishermen from the little harbour of Portscatho in Gerrans Bay, between Falmouth and Mevagissey, encountered what they described as a serpentine creature just 500 yards from the shore. As they approached it the creature lifted its head and appeared aggressive, so they attempted to whack it with their oars, eventually disabling it sufficiently to drag it ashore still alive. Being out of the water soon led to the creature expiring on the rocks, so the villagers threw it back into the sea. The newspaper (and this writer) found this hard to understand, asking why it had not been preserved in the cause of science and exhibited to bring some income to the village.

A second detailed encounter was recorded by Ed Boddaert, a thirteen-year-old boy who had joined the crew of the *Ibis*, a Mevagissey fishing boat, in the autumn of 1944. It was a calm evening and in the search for pilchards the crew encountered a whale, before darkness fell. Pilchards were hard to find and had possibly been scared away by the whale. Suddenly, Ed describes the sea parting

The harbour, Portscatho.

off the starboard beam some 12 feet away and 'a large object with a ball-like head rose out of the water'. The fishermen, all seasoned hands, were staring with open mouths. After a few seconds the creature let out a breath and disappeared below the surface, never to reappear. Beyond knowing that it was neither a whale or a submarine periscope, they had no idea what they had seen.

During the 1970s, there were a significant number of reported sightings of a hump-backed creature off Falmouth. In 1975, a couple out walking on Pendennis Point saw a large long-necked sea monster, having stumpy horns, apparently catching a conger eel. In 1976, a photograph was published in a local newspaper purported to have been taken by 'Mary F' at nearby Trefusis Point. She estimated the beast to be 15 to 18 feet long and with a long neck culminating in a small head, the whole thing resembling an elephant's trunk. The original of the published photograph was never located and some experts believe it was a hoax. The were a total of seven sightings that year, a particularly hot summer. During the 1980s and '90s sightings continued to occur sporadically, and included the first video footage ever recorded. The stretch of coast around Toll Point at the mouth of the Helford has become known as 'Morgawr Mile' on account of the number of sightings there.

Some scientists have theorised that Morgawr is one of a number of living fossils, probably plesiosaurs, still living in the ocean and occasionally coming to the surface. If only the fishermen of Portscatho had preserved their specimen, we might have known for sure.

Toll Point, Helford, start of 'Morgawr Mile'.

The Wreck of the *Association*

In 1707, Admiral Sir Cloudesley Shovell was in command of the British fleet in the Mediterranean. The twenty-one-strong fleet set sail for home on 29 September led by the flagship HMS *Association* with Shovell and his stepsons aboard. As they neared the Western Approaches, the weather became stormy and heavy squalls caused the fleet to drift off course. By 22 October Shovell was worried enough to summon his senior commanders to a meeting aboard the flagship. The only method they had of determining their position was by so-called dead reckoning, a term which turned out to be all too prophetic. Since they had no way of reliably determining longitude, this was essentially guesswork based on the estimated speed and course of the ship. They took soundings of the depth of water and determined that they must be close to land, which the majority believed was Ushant near the coast of Brittany. The only captain to dissent was Sir William Jumper, from HMS *Lenox*, an experienced navigator whose calculations put the fleet within three hours of the Isles of Scilly, much further north. However, he was outvoted and the fleet set their course accordingly.

As darkness fell, Shovell sighted the lighthouse on the island of St Agnes, the most southerly of the Scillies. Believing he was off the coast of France, he adjusted his course to the west, sealing his fate. Shortly afterwards at 8 p.m. the *Association* hit the Gilstone rock off Peninnis Head on St Mary's. She sank almost immediately with the loss of 800 crew and 100 passengers. Three other warships were also lost, at a cost estimated at £23,000 (over £4 m today) and bringing the death toll to 2,000 sailors, some of whom now rest in the shade of Old Town church just outside Hugh Town, including Henry, son of Bishop Jonathan Trelawny of Pelynt. Shovell, his stepsons, Captain Loades and his dog managed to get into a lifeboat but their bodies washed up next morning at Porth Hellick on St Mary's.

There is a twist to the tale, however. A persistent legend says that Sir Cloudesley was still alive when he was found that morning by a Scillonian woman. Before raising the alarm, she spotted an ornate gold ring with a large emerald on the Admiral's finger, said to have been a gift from Lord James Dursley. Instead of trying to save him, she killed him and removed the ring, probably realising almost immediately that such an item could never be sold without raising suspicion. Meanwhile the bodies were buried where they were found in a crude grave. Later, on Queen Anne's orders, Shovell's body was exhumed and buried with due ceremony in Westminster Abbey on 22 December 1707. Meanwhile the fact that the Admiral's ring was missing had been spotted and a reward offered by his widow. Twenty-seven years later a Scillonian woman on her deathbed confessed to the local priest that she had stolen the ring, which was returned to the family of Lord Dursley. William Bottrell, writing in 1873, gives a different account in which the Admiral's body was found by a soldier who recognised the ring and returned it to Lady Shovell, who rewarded him with a life pension.

Porth Hellick beach, St Mary's.

Old Town churchyard, St Mary's.

In 1714, as a direct result of the disaster, Parliament passed the Longitude Act which offered a reward of £20,000 to anyone who could devise an accurate method of determining longitude at sea. It took until 1759 for John Harrison to solve the problem with his invention of the chronometer, although he never received the full reward. In 1967, a Royal Navy diver, Richard Larn, located the wreck of the Association and began recovering cannons, plates, and coins which he donated to the *Valhalla* museum on the island of Tresco. Larn's team made over 1,500 dives, following which amateur divers descended on Scilly and looted the site. No official record was ever kept of the treasure removed, and it is said that eighteenth-century coins were so plentiful they were used as currency to buy drinks in the island's pubs!

The Wreck of the *Hope*

Visitors to the island of St Martin's in the Isles of Scilly will be familiar with the red- and white-striped daymark on its most northerly point. It is inscribed with the date 1637, although it was actually built in 1683. However, it has not always been so vividly coloured, originally being painted white. The red stripes were added as the result of a disaster which happened on 19 January 1830. The *Hope* was returning from Ghana loaded with a valuable cargo of elephant tusks, palm oil, gold and silver. In a violent storm Captain Noble glimpsed the white-painted daymark and mistook it for the similarly painted lighthouse on St Agnes, the most southerly of the islands. Within minutes his ship had foundered on the rocky foreshore of St

(left) St Martin's daymark lighthouse; *(right)* St Agnes, Isles of Scilly.

Martin's and all the crew and passengers were lost, some killed by the mast which fell on them as they were abandoning ship. Among them was an unnamed African boy who is remembered in a memorial in the churchyard on the island. It reads:

In Memory of a young West African boy, buried here after the HOPE was wrecked on St Martin's Head due to mistaking the white daymark for St Agnes lighthouse, 19th January, 1830.

Red stripes were then added to the daymark. I will set your captives free, Zech. 9.11.

Henry Trengrouse and The Wreck of the *Anson*

Born in 1772 at the family estate of Priske near Mullion, Henry Trengrouse became a cabinetmaker in Helston. On 29 December 1807, rumours were circulating about a shipwreck off Loe Bar, a short distance away, so he left his workshop and joined the crowds of people hurrying to the scene. Amid enormous seas, a naval frigate was broadside on to the beach and being battered by the waves. As Henry watched, her mainmast crashed onto the shore, killing some men but forming a bridge across which others managed to scramble ashore, but many more were drowned after an unequal struggle with a combination of the huge swell and the retreating tide.

The frigate was the forty-four-gun HMS *Anson* and she had left Falmouth on Christmas Eve bound for Brest. Over the next few days, a south-westerly gale blew up and intensified and, with the ship struggling to make headway, Capt. Lydiard made the decision to return to port. As the ship approached what he believed was the Lizard, the lookout shouted a warning that there were breakers ahead. Lydiard realised too late that they were actually off Mount's Bay and being blown onto rocks. He hoped that by dropping both anchors he could hold the ship until the storm abated, but by dawn the strain was too much for the cables and the warship's fate was sealed. Lydiard managed to use the onshore wind to manoeuvre the vessel onto the sandy ridge of Loe Bar, where the mountainous seas turned her broadside on, the ship heeling over and coming to rest 100 yards from the beach. The crowd of men, women and children who had assembled watched helplessly as the bodies, well over a hundred of them, washed up onto the beach. There was little any of the watching crowd could do, for getting aboard the ship was virtually impossible given the conditions. Henry Trengrouse managed to swim out to the ship and rescue a child, also dragging a drowning man to safety. The event made a huge impression on him, and he was haunted by the sight of the drowning men for many weeks afterwards. He became obsessed with the idea of developing a rescue device, and experimented initially with ideas for a lifeboat, later developing a self-righting design and a cork lifejacket. In order to rescue men from a sinking ship like HMS *Anson*,

he really needed a way of attaching a line from the ship to the shore, which could then be used to winch men to safety. A flash of inspiration came, literally, during Helston's firework display in celebration of the birthday of King George III. As he watched the rockets soaring into the darkness, he realised that a line could be attached to the stick and fired into the shipwreck, or indeed, vice versa, from the ship to the shore. As it happened, a similar idea was being tested by George Manby, inventor of the fire extinguisher, who had witnessed a similar wreck on the Norfolk coast. Instead of a rocket he was using a mortar shot. This concept suffered a number of drawbacks, safety for one, but also the rapid acceleration of a heavy mortar frequently caused the line to break. Trengrouse's rocket solved these problems: the rocket left a trail of sparks which indicated its path, it accelerated less rapidly, and was much lighter than a lead ball. Trengrouse now devoted all his efforts, and his means, to developing his life-saving apparatus. It is fair to say it became his obsession, spending some £3,000 on his idea over his lifetime. He made frequent trips to London, trying to interest the government, but the response was slow, unlike that of the Russian government, who stepped in to offer all the resources he needed to develop the device. The patriotic Trengrouse turned them down, and continued battering at the door of the Admiralty until 1818, when he was at last able to demonstrate his rocket device to naval Commander-in-Chief Sir Charles Rowley. Reports were favourable, and Trinity House concluded that no vessel should be without his life-saving equipment. Eventually, the government agreed to purchase twenty of Trengrouse's rockets, but wanted them manufactured by the Royal Ordnance

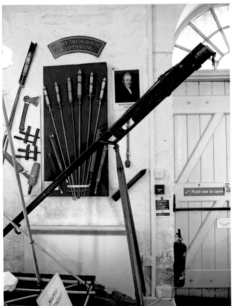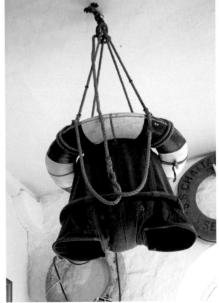

Early rocket lifesaving equipment, Museum of Cornish Life, Helston.

factory. Trengrouse received £50 compensation, and was later awarded a Silver Medal and a prize of £30 from the Society of Arts. He also received a diamond ring from the Czar of Russia, Alexander I, which later in his life he was forced to pawn. Henry Trengrouse died in 1854 having spent most of his energies and all of his money on this life-saving project. In time, his invention, improved and modified, became second only to the lifeboat as a means of saving lives at sea. The excellent Museum of Cornish Life in Helston has a small exhibition dedicated to him.

The wreck of the *Anson* was important in another way. There was widespread anger that the bodies of the victims were hastily buried in pits dug at the scene without any religious rites. Local solicitor John Grylls framed an Act of Parliament which was presented to the house by MP John Tremayne. The Burial of Drowned Persons Act, also known as the Grylls' Act, was passed in 1808 in order to provide burial in consecrated ground for all victims of shipwreck. A monument to the disaster overlooks Loe Bar, and another to the Grylls' Act stands on the cliff to the west of Porthleven harbour, which itself was constructed as a result of the tragedy in order to provide some shelter for shipping in the centre of Mount's Bay.

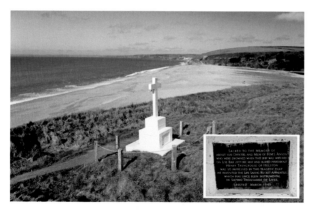

Memorials to HMS *Anson*, Loe Bar (*above*) and the Gryll's Act, Porthleven (*below*).

The Drowning of Sister Emilie

In June 1908, a group of twenty-two teenaged girls arrived to stay at the Manor House at West Pentire for a fortnight's holiday by the sea. They came from Rosewin Training School for Servants in Truro, which was run by an order of nuns belonging to the Community of the Epiphany in the city. In charge was Sister Emilie, who had been the headteacher at the school since 1897. With her were Isabella Miriams, who was studying Japanese at the convent prior to becoming a missionary, Nurse Fry and the school matron, Annie Lawrence. On the morning of 23 June, a group of girls were sitting on rocks overlooking the sea, together with Miss Miriams, Nurse Fry and Matron Annie. Matron Annie later gave the following account to the *West Briton*:

> We were sitting on the rocks, myself, Nurse Fry and some of the children, and had been there about 10 minutes when a huge wave came and swept us off. Nurse Fry, myself and the bigger girls struggled to the rocks, but three of the younger girls had no strength and were washed away. They were Annie Sophia Frost, who came from Essex, Jane Mary Searle of Penzance, and Dorothy Wood of London. I went back behind the rock and told Sister Emilie that three children had fallen into the sea. She immediately sprang down to

Crantock beach.

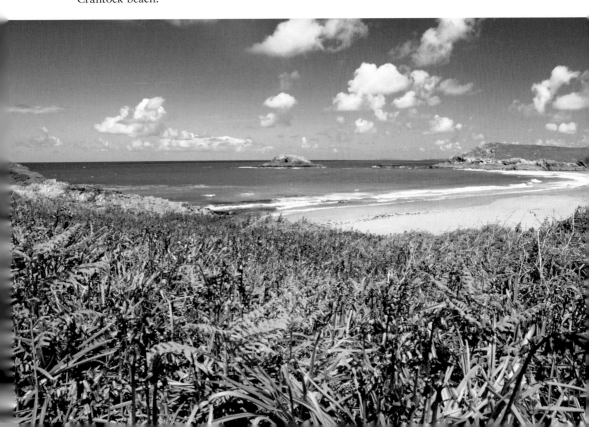

save them. I said 'Sister, don't go in' but she went in and a second big wave came and, of course, she was swept off her feet, and her head came in contact with a rock. She must have been stunned by the blow, for she apparently made no effort to recover herself, and was carried out to sea. We ran for Miss Miriams, who we knew could swim, and she came at once and went into the water to try and save Sister Emilie, who we could see. She swam as far as she could, and finding her strength fail, Mr Rowe went out for her, caught her hold and brought her ashore. Captain Fenton who was staying as a visitor at Pentire, went out and saved Dorothy, and Mr Rowe and Mr Ellis, Crantock farmers, went out to see if they could render any assistance to either of the girls or Sister Emilie. There were plenty of others, but their efforts were in vain. Miss Miriams and Dorothy Wood were eventually brought ashore in an exhausted condition.

Matron Annie continued:

Besides the four I have mentioned, others of our party had narrow escapes. I was thrown across on my back, but managed to catch hold of a child's foot, and we clung onto the rocks together and were saved

Asked if there was any risk to being where they were, Matron Annie replied:

Oh no. The tide was going down and we were on a rock in a position that was a reasonable height from the water. There was apparently not the slightest risk, but the two waves must have been tidal waves, and they were huge compared to those preceding them.

In fact, locals believed that the wave was what they called a ninth wave, which occasionally ran to a much greater height and which could run up the Gannel like a bore for a mile or more.

The Crantock burial register records that a great wave swept the two girls Annie and Jane from the rocks and they were drowned. Their bodies were recovered and buried in Crantock churchyard. Sister Emilie's body was not recovered until a fortnight later, when it was found by a fisherman still floating face-downwards several miles up the coast near Trevose Head. Revd Parsons added a handwritten note to the burial register (which can be inspected at Cornwall's Record Office) recording that it appeared unaffected by any trace of decomposition and her clothes were undamaged. She is buried in the churchyard at St Endellion and a memorial service was held in the cathedral, where a plaque to her memory was unveiled. As a postscript to the story, Miss Miriams was later awarded the medal of the Royal Humane Society for her actions that day.

Rough seas near Crantock. (Photo: Barbara Husband)

7

People

Anthony Payne, the Cornish Giant

No legendary giant, Anthony Payne was born the son of a tenant farmer in 1612 in the village of Stratton. He grew up to weigh 32 stones and his height is recorded as 7 feet 4 inches. He retired to the house where he was born, now the Tree Inn, and when he died in 1691 the only way for his coffin to leave the house was through the ceiling, after first sawing through the joists.

It was not surprising, given his physique, that Anthony Payne became a bodyguard to Sir Bevill Grenville, a Royalist general, and later his brother Richard. Despite his girth, he was reputed to be quick-witted and agile. During the Civil War, Grenville with Payne at his side took part in two Cornish battles, most famously at Stratton, where on 16 May 1643 the Royalist Cornishmen routed the assembled Parliamentarian army, comprising 5,600 men, in the Battle of Stamford Hill, between Bude and Stratton. It was said that the huge figure of

The Tree Inn at Stratton.

Payne, mounted on his cob Samson, and brandishing his halberd, a long-handled axe, terrorised the enemy. The Tree Inn became the base for Grenville and his prisoners. A month later, Payne was present when Grenville was killed during the Battle of Lansdowne Hill near Bath, and brought his master's body back to be buried at Kilkhampton. Later, in 1680, Charles II, who held the Cornish giant in high regard, instructed a leading artist of the day, Sir Godfrey Kneller, to paint his full-length portrait as a gift to Sir Bevill's son, John of Stowe, the Earl of Bath. This portrait hangs in the Royal Cornwall Museum, and shows Payne dressed in his scarlet uniform of a Halberdier of the Guns of Plymouth Citadel, where he and Grenville were based. When the Earl of Bath's seat of Stowe was demolished in 1739, the painting was lost, and was eventually found rolled up in the possession of a farmer's wife who claimed it was 'a carpet with an effigy of a large man on it', and who gladly sold it for £8. A reproduction of this painting can be found in the Tree Inn and is reproduced on the inn sign. Also on the wall of the inn is a copy of the plaque commemorating the battle which was originally placed at the battle scene by Sir Bevill's grandson in 1713. The site of the battle can be found just off the A39 near the turn-off for Stratton. A stone memorial to Grenville can be found in an adjoining field, on privately owned land.

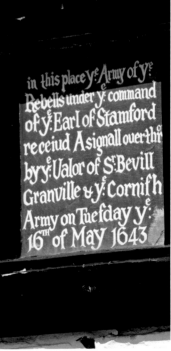

Tree Inn, Stratton (*left*), Anthony Payne's portrait (*right*), copy of the inscription from the Stamford Hill battle site.

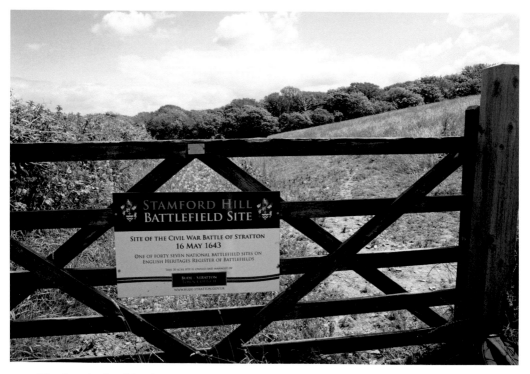

The Stamford Hill battle site near Stratton.

Jonathan Trelawny

Celebrated in song every St Piran's Day, Trelawny is probably the most famous Cornish hero of them all, although few of those raising their voices in the Cornish national anthem know much about his exploits. Jonathan Trelawny was born in 1650 at Trelawne near Pelynt, the son of the baronet of the same name. He excelled in religious studies, attended Oxford University and in 1673 was ordained, serving at South Hill and later St Ives. In 1685, together with his brother, Major Charles Trelawny, he lent his support to James II in helping to muster an army to defeat the rebel Duke of Monmouth at Sedgemoor, for which he was rewarded with the Bishopric of Bristol. Two years later James II put himself on a collision course with the church when he introduced his Declaration of Indulgence, which proposed allowing Catholics greater religious freedom. In 1688, Trelawny and six of his fellow bishops presented James with a petition opposing the act, and the king reacted by imprisoning all seven bishops in the Tower charged with seditious libel. There was considerable anger in Cornwall but they certainly did not muster 20,000 men to march on London's Gate to demand the reason why, as the song states.

Trelawny and his fellow bishops were tried and acquitted, with much rejoicing in his home village. He went on to become Bishop of Exeter and later Winchester, although he was somewhat of an absentee incumbent with most of his priests

having to travel to Cornwall for their ordinations. Following his death in 1721 he was buried at Pelynt. The church of St Nun contains the Trelawny family vault and quite a few artefacts, including his bishop's crook, used in his funeral procession. In 1882, the coffin plate was removed from the vault and placed on display in a niche in the church. There it remained until 2016, when it was stolen. It reappeared two years later in a charity shop in Norwich and after some research was returned to its rightful place. There is also a wall tablet to one of his predecessors, Edward, with an amusing inscription, so that we leave with a smile on our face:

Heere lyes an honest lawyer, wot you what, a thing for all the world to wonder at.

Trelawny was immortalised in the poem which has become the Cornish national anthem, 'The Song of the Western Men'. It was written in 1825 by Robert Stephen Hawker, eccentric rector of Morwenstow in north Cornwall, and set to music by Louisa Clare in 1861. It was published anonymously in a local newspaper, a mistake from the perspective of Hawker's royalties after its popularity soared. Such literary figures as Sir Walter Scott and Charles Dickens believed the song was an authentic composition from Trelawny's day, and we can be certain that a similar song was popular at the time. Some historians link the poem to a song dating from Napoleonic times called 'Ye Jolly Tinner

The Trelawny aisle, St Nun, Pelynt.

Boys' which contains the line 'And forty-thousand Cornish boys shall know the reason why', remarkably similar to Hawker's, apart from the scaled-down size of his army. The most convincing evidence is found in the parish records of St Tudy, where Revd Edward Trelawny was vicar in the last decade of the seventeenth century and who recorded the following lines: 'And shall Trelawny die? We are twenty thousand will know the reason why'. There are echoes here of an earlier uprising in 1497 when Michael Joseph, a blacksmith from St Keverne, and Thomas Flamanck, a lawyer from Bodmin, led a Cornish army of 15,000 men in protest against taxes imposed by Henry VII. They marched peacefully to Blackheath but were outnumbered by 25,000 of the king's men, with predictable results: both of the leaders were hanged, drawn and quartered. Other writers have pointed out the irony that Hawker, who converted to Catholicism on his deathbed, should celebrate an act of religious intolerance against his adopted church.

John Knill and His Quinquennial Ceremony

John Knill was born at Callington on New Year's Day 1733. He became a clerk with a Penzance lawyer, and in 1762 was appointed Collector of Customs in St Ives, a post he held for the next twenty years. In 1767, he was appointed Mayor. There are stories that Knill colluded with the smugglers, nonetheless between 1773 and 1774 his abilities as a customs officer led him to be chosen for a mission to Jamaica on behalf of the government Board of Customs. In 1782, he resigned from his St Ives post and moved to London, where he was called to the bar at Gray's Inn. The same year he erected a mausoleum on Worvas Hill overlooking Carbis Bay. The design was a 50-foot-high pyramid constructed of granite blocks, drawn up by architect John Wood in 1779 and constructed by a local builder. On one face of the pyramid was carved the word 'Resurgam': 'I will rise again', beneath which was placed the arms and motto of the Knill family, 'Nil desparandum' (a clever play on words). The second face bore the text 'I know that my Redeemer liveth', and the third face carried his name, and the date 1782. The steeple, as it became known, is visible for miles out to sea, a useful navigation mark for sailors.

Knill intended the pyramid to be his tomb, but objections from the church authorities regarding its consecration led to a change of heart, and he left instructions for his burial in St Andrew's Church in Holborn, where his body was interred on 11 March 1811. In later life he became a patron of the arts and an inveterate traveller, making numerous journeys around Britain on horseback. It seems that Knill had a desire to be remembered long after his death and so instituted a ceremony to be performed on 25 July, at five-yearly intervals, leaving a sum of money in trust in order to ensure its continued survival. In so doing he created a tradition that has survived for over 200 years and whose simplicity and charm takes us back to more innocent times. The first enactment, which Knill participated in, took place in 1801.

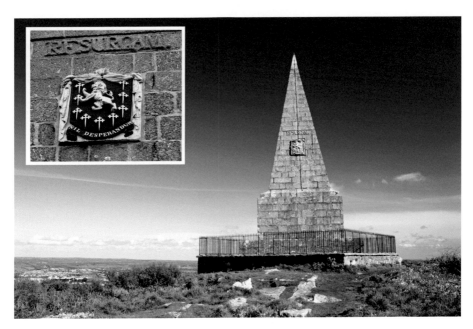

John Knill's mausoleum, St Ives. (*Inset*) Knill coat of arms.

Knill's legal training ensured that the instructions for his ceremony were set out in meticulous detail in a deed drawn up in 1797. Three trustees were appointed, to be made up of the Mayor, the Vicar of St Ives, and a Customs Officer. His estate was to pay the trustees £10 each year, £5 of which was for the upkeep of the mausoleum, and the rest accumulated over five years to pay for the ceremony. This was apportioned as follows: £10 for a dinner for the trustees and six guests, and 10 shillings (50p) each for ten young dancing girls under ten years of age, who were to be chosen from the daughters of miners, fishermen or seamen. £1 each was given to two widows from these same occupations, £1 for white ribbons to be worn at the ceremony, £1 to pay for a fiddler to provide music, and £1 for the town clerk's expenses in organising the event. The remaining £5 was to be given to a married couple who were judged to have raised the largest family in the town without help from the poor fund. Funds from Knill's original bequest have long since run out but the trustees have been fortunate to have received gifts from benefactors keen to see the tradition continue.

The ceremony, sometimes referred to as the Knillian, begins outside the Guildhall in the centre of the town. John Knill's iron deed box, with its three brass locks, is brought out and placed on a table in front of the steps. At 10.30 a.m., the Mayor, Vicar and Custom's Officer are led out of the Guildhall by the MC, smartly attired in morning dress. The ten girls, dressed in white and wearing garlands in their hair, line up in front of the chest while the two widows, dressed in their weeds, stand to the side. The fiddler, in 2016 folk musician Mike O'Connor (dressed in eighteenth-century costume and wearing a tricorn hat), takes up his

position and the MC introduces the trustees and explains the procedure to the watching crowd. The trustees each have a key to one of the locks, and after all three keys have been inserted, the lid is opened. Inside are purses containing the payments and white ribbons which are handed out to the participants. The trustees have made allowance for inflation, and today the girls receive £5 each, the widows £10 and the fiddler £20. After these have been presented, a procession forms with the fiddler leading the ten girls, followed by the widows and the officials and trustees bringing up the rear. The fiddler plays the Cornish Furry dance tune (the same as is used to accompany the dancing at the nearby town of Helston's Flora Day on 8 May) as the procession weaves its way around the streets from the Guildhall up the hill to the Malakoff, overlooking the harbour. In Knill's day, the participants would have walked the mile or so uphill to the steeple, but today they go by 'bus, arriving at exactly twelve noon. The waiting crowd have meanwhile been entertained by local folk musicians and dancers. Among them will be proud parents and grandparents of the children taking part, some who will have taken part when they were girls. There are usually some of Knill's descendants among the throng; in 1991, a group from California attended. Following a brief introduction from the MC, standing under Knill's coat of arms, the trustees, fiddler, widows and the ten girls dance around the ledge at the base of the steeple, which is today safely encased behind iron railings. The MC and trustees take turns to dance with the widows. Then all join with cheerful voice in the singing of the Old Hundredth psalm, 'All People that on Earth do Dwell', accompanied by the fiddler. 'Seldom have we heard this grand old hymn of praise sung under the broad canopy of heaven in such picturesque and romantic

John Knill ceremony, (*left*) his chest, (*right*) the procession through the streets of St Ives.

Fiddler Mike O' Connor leads the procession to the steeple.

conditions' to quote a newspaper account from the 1920s. Then the dancers do their final turns around the steeple before the MC winds up proceedings for another five years. His last duty is to ask the trustees if they agree that their benefactor's wishes have been carried out to their satisfaction.

George Martin: St George of Southwark

Revd George Martin's move from Cornwall to London was based on a deep religious conviction to live out the gospel in an act of self-denial. Martin was born at St Breward in 1864, the son of Revd Dr George Martin, who was rector there. The family were wealthy and young George was sent to Blundell's School in Tiverton where he excelled in classical studies. From here he gained a place at St John's College, Cambridge, where his interest in ancient Greek developed alongside his studies for the priesthood. In 1887, he was ordained a deacon in the Diocese of Truro, and a priest a year later. His first appointment was at Duloe, moving to Marhamchurch in 1891. In 1893, he became rector of Caerhays, on the south coast, where the church of St Michael, with its squat tower, dates from Norman times.

Whilst at Caerhays, Martin took long walks along the coast. He became fascinated by the rocky headland known as the Dodman, or Deadman, the most

(*left*) Dodman cross; (*right*) the church of St Michael, Caerhays.

southerly point between Rame Head and the Lizard. He often spent the night there in a lonely vigil, returning after watching the sunrise. In 1896, he paid for the erection of a tall granite cross, 15 feet high, which stands exposed to the westerly winds looking out across Veryan Bay. It bears the inscription 'In the firm hope of the second coming of Jesus Christ, and for the encouragement of those who strive to serve him, this cross is erected AD1896'. A year later, in September of 1897, two naval destroyers, the *Thrasher* and the *Lynx*, were wrecked on the rocks below the cross in a thick mist. A third vessel, the *Sunfish*, narrowly avoided the same fate. Three sailors and a coastguard officer lost their lives in the tragedy. Just two years later, in 1899, aged thirty-five, George Martin resigned his £700 a year job for life at Caerhays and moved to London's east end, where he spent the next forty-eight years. His intention was to work alongside the poorest people in the land, taking a porter's job for 18 shillings (90p) a week at Borough Market and living in a small room eating only bread and margarine from a slate. His wages were spent on his neighbours, daily treating eighteen of the poorest to a meagre meal at a tearoom. When one of his friends at the market was too ill to work, Martin shared his wages until the man recovered. When a child became ill, he spent nightly vigils by the child's bedside so that his father could get some sleep and go to work. With his long straggly beard, workman's boots and ragged frock coat he became a well-known figure in the east end, the press calling him the

'modern day St Anthony' and 'St George of Southwark'. He was a socialist and in 1902, incensed at the money being spent erecting stands in front of Southwark Cathedral for the privileged to watch the coronation procession of Edward VII, he was forcibly removed from the grounds of Buckingham Palace trying to deliver a letter of protest. On the morning of the coronation, well before any crowds has assembled, he was arrested for trying to blow up the stands with a homemade bomb 'to strike a blow for Christ', he said, refusing offers of leniency from the magistrate.

In 1934, he sustained severe injuries after being run over by a lorry, and was treated at Guy's Hospital, just across the road from his room. Despite living in apparent penury, his family inheritance meant that he was actually a wealthy man. After his death in an institution in 1946, he left a considerable legacy, split between the poor of the Borough of Southwark (who received an astonishing £22,000, worth just under £1 million today) and his old college at Cambridge, who received £1,000 to fund a scholarship for Cornish students training to enter the church.

Martin's time in the east end covered two world wars, including the Blitz, and the depression. A fellow churchman wrote this obituary:

> Everyone loves him, and while his ragged appearance might otherwise make him the butt of laughter, his personality is so strong that he is wonderfully respected. He has done untold good, living among the poorest of the poor and doing all his own work ... to me he has always seemed saint-like.

Sunset over Veryan Bay.

What's in a Name

Some places in Cornwall have odd and amusing names, often relating to a tale or two. Here are just a few of them.

Knave-Go-By

No more than a hamlet on the southern edge the mining town of Camborne, the odd name is said to derive from a visit by John Wesley, founder of Methodism, who preached in the village several times, it is said, from an elm tree, now dead, in the centre of the hamlet. One version of the tale says that among the established Anglicans, Wesley was referred to as a knave and the story suggests that these folk wanted him to stop preaching and move on. Another, related, version, suggests that Wesley himself used the phrase after being heckled by a youth, whom he referred to as a knave. Before Wesley's day, however, the out-of-the-way hamlet was known as Never Go By, and we infer either that the Wesley story is an invention, or that the name of the village was changed by one word as a result. Readers should note that the village is not connected with a book published in the 1950s entitled *Knave-Go-By: The Adventures of Jacky Nameless* which is set on Dartmoor.

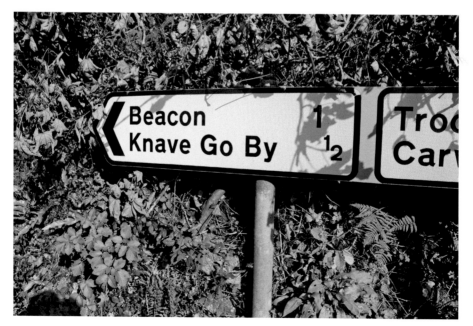

Knave-Go-By has a connection to John Wesley.

John Wesley preaching (Truro Cathedral).

Indian Queens

A large village in mid-Cornwall next to the A30, Indian Queens gets its name
from the village inn. Up until 1780, the inn had been known as the Queen's
Head but around that time its name changed to the Indian Queen. Later in the
mid-nineteenth century, the inn sign displayed a portrait of Queen Victoria,
Empress of India, on one side and a picture of a Native American princess on
the other, both possible interpretations of the name. For many years the Indian
Queen in question was thought to be Pocahontas, who legend says in 1616
lodged nearby after arriving in Falmouth from America and then travelling
by coach to London. It was recently discovered that Pocahontas' ship actually
docked in Plymouth, meaning that her journey across Cornwall never took
place; this did not, however, stop a housing development in the village being
named Pocahontas Crescent after her. A second story, very similar to the
first, is that in the late eighteenth century a Portuguese princess landed in
Falmouth and travelled to London with an overnight stop at the inn, the locals
mistaking her ethnicity. The inn was demolished in the 1960s, but the sign
is kept in the Royal Cornwall Museum in Truro. The inscribed stone lintel
can be still be seen adorning the front of a house in the village, and reads:
'The Indian Queen: Licensed Brewer and Retailer of Beer, Cyder, Wine and
Tobacco, Licensed Post Horses'.

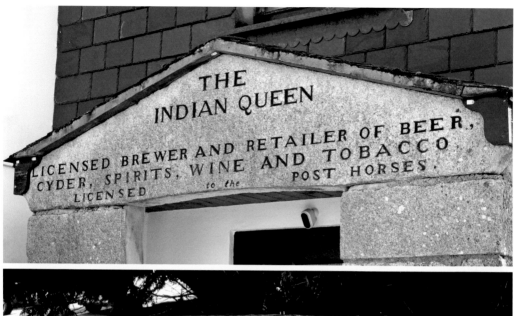

Indian Queen's (*top*) lintel from the old inn; (*bottom*) Pocohontas Crescent.

London Apprentice

This village, between St Austell and Pentewan, also seems to have been named after an inn, although there is none in the village today. The name is first recorded on a map in 1747, and it seems likely that it was taken from a very popular ballad of the time, *The Honour of a London Prentice*. It tells the story of an apprentice from London who travels to Turkey and kills twenty knights who besmirched the honour of Elizabeth I. The king is furious and sends his son, the prince, to deal with the apprentice, but he too is killed. The king has the apprentice thrown into an arena with two starving lions, but the apprentice manages to kill them as well, and in spectacular fashion, by reaching down their throats and ripping out their hearts. This convinces the king that England is the more powerful nation and he offers the apprentice his daughter's hand in marriage. That this unlikely tale is the origin of the name of a small Cornish village is indeed surprising, but London has three pubs of the same name, and Birmingham also had a London Apprentice Street.

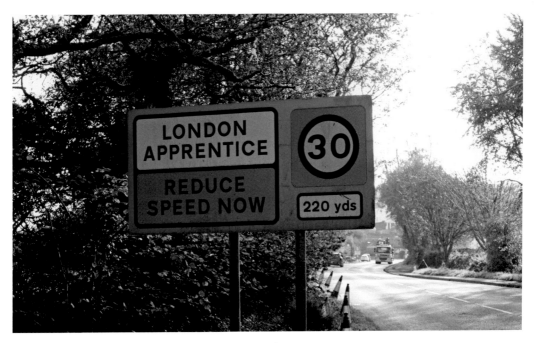

London Apprentice traces its name to a popular song.

The Bucket of Blood Inn, Phillack
This eighteenth-century pub, near Hayle, has a gruesome name and an even more gruesome sign. It derives from an incident in which the landlord, attempting to draw a bucket of water from the well, instead drew up a bucket filled with blood. It appears that the body of a local smuggler had been disposed of down the well, contaminating the water. However, a more likely explanation is that the water was contaminated with iron oxide from mining waste, since nearby at Gwithian we find the mouth of the Red River, which also ran red from the tin mines along its 7-mile-long journey and which has recently been called the country's most altered watercourse.

Vogue
A tiny hamlet between St Day and Redruth, Vogue derives its name from a Cornish word 'fog' meaning a smelting or blowing house. In 2022 Mark Graham, the landlord of the village inn, The Star Inn at Vogue, registered his business with Companies House and soon after was surprised to receive a letter from the owners of a famous fashion magazine of the same name asking him to cease and desist using the magazine's name in case a connection between the two businesses was inferred. The landlord replied that the village had been so-called since the 1700s, much earlier than the magazine's founding in 1916, and suggested that the magazine should instead change its name. He received an apologetic letter from the magazine's owners which takes pride of place in the bar.

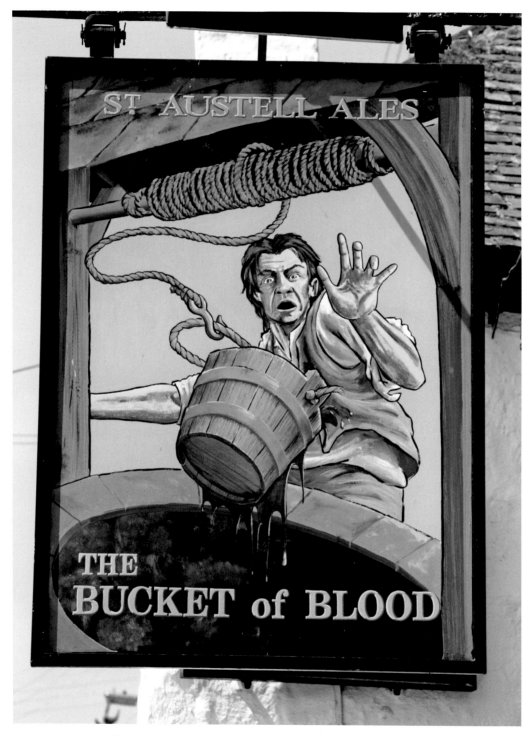

The Bucket of Blood inn sign, Phillack.

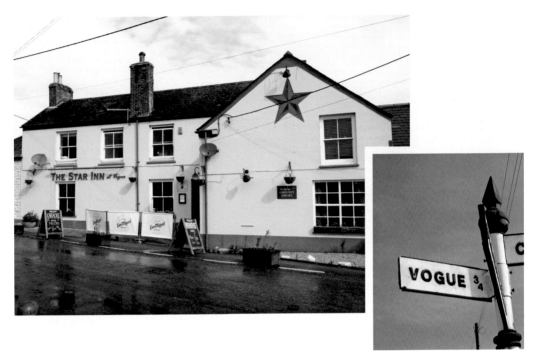

The Star Inn at Vogue.

Strange but True

The Methuselahs of Stratton

The parish of Stratton near Bude has produced some of the longest-lived people in Cornwall. A man named Chamont is said to have reached the grand old age of 130 and was an uncle or great uncle to 360 children, although there are no records in existence to prove it. However, there are parish records confirming that John Veal and his daughter Elisabeth Cornish both lived to well over 110 years. John Veal, born in the sixteenth century, died aged 114 years and 4 months and was an early vegetarian, ascribing his longevity to 'never drinking spiritous liqueur, rising early and never eating meat'. His daughter Elisabeth died in 1691 aged 113 years and 4 months, as a result, she said, of 'rising at sunrise, going to bed at sunset and sniffing a freshly-dug turf every day'.

The pretty village of Stratton had some long-lived inhabitants.

Thomasine Bonaventura

Born in north Cornwall around 1450, Thomasine Bonaventura was aptly named. She was the daughter of a sheep farmer, and, but for one momentous day, would no doubt have married and raised a large family in the village of her birth, Week St Mary, just south of Stratton. She spent her days out on the moors tending her father's flock, and on this particular day was approached by a rich wool merchant with his entourage, probably carrying fleeces, making his way back to his home in London. He stopped to pass the time of day, and was so impressed by her polite conversation that he questioned her further on her family background before offering her a job as his wife's maid, provided that her father agreed to let her travel with him to the capital. This was forthcoming and Thomasine became a maidservant to the merchant's wife. All went well for some time, and then tragedy struck when her mistress became ill and died. In due course the merchant, Richard Bumsby, offered Thomasine his hand and she became his second wife. The marriage lasted for three years and then Bumsby died, leaving Thomasine a wealthy widow. Not surprisingly, she was courted by another merchant, John Gall, and she married for the second time, using some of her fortune to purchase 20 acres of woodland in Week St Mary to help the poor of the parish. The second

The village green, Week St Mary.

marriage lasted for five years until John Gall also died, leaving her his estate, and so Thomasine became even wealthier. She married for the third time, to John Percival, a banker and member of the Guild of Merchant Tailors, who in 1498 went on to become Lord Mayor of London, when he was knighted. The couple continued their charitable donations, Thomasine paying for a road to be built to allow better access to her home village. You can probably guess that when Sir John Percival died in 1504, she inherited his wealth also, and as Dame Percival in 1508 founded a chantry and free-school in the village, providing a yearly sum for maintenance. We learn from Carew that 'the best gentlemen's sons in Devon and Cornwall were there trained … under one Cholwel, an honest and religious teacher'. Thomasine died without children in 1539 aged eighty-nine, and was buried beside her last husband at St Mary Woolnoth, in the city of London. In her will she left detailed instructions for the distribution of her wealth, looking after family, the poor, and the church, as well as her school in her home village and money to build a church tower in Launceston. Some think her endowment provided funds for the very impressive tower of St Mary's Church in her village. Her school did not last for long, as in 1547 a young Edward VI had succeeded Henry VIII and continued his father's policy of confiscating church schools and chantries, so that by 1550 Dame Percival's school was moved to Launceston and eventually became Horwell Grammar School. The building, much altered, became a farmhouse and is now a holiday cottage owned by the Landmark Trust. Its ecclesiastical stonework, notably the carved tympanum, still testifies to its original purpose.

Dame Percival's school, Week St Mary, now a holiday cottage.

The church of St Mary, Week St Mary.

The Arrest of Captain Bligh

Captain William Bligh, who grew up near St Tudy, is famous as the captain of HMS *Bounty* and will be forever associated with the mutiny which took place near Tahiti in 1789. Cast adrift in a small boat with eighteen loyal crew, they managed to navigate the 4,000 miles to the Dutch East Indies and safety. In 1803, the Admiralty, preoccupied with the threat of French troops landing somewhere quiet on the south coast, and aware that Bligh was trained in surveying, gave him the job of surveying some Cornish harbours as potential enemy landing sites. He travelled to Plymouth by coach, dressed in civilian clothes to avoid being spotted by French spies. Having crossed the Tamar at Torpoint, he took another coach to Falmouth before travelling on to Helford. He began his survey in Gillan Creek, taking soundings, placing flags and daubing whitewash on rocks. However, he was spotted by local constables who, ironically, suspected he was a French spy, so they arrested him and took him to the vicarage at Manaccan, where the local rector, Revd Richard Polwhele, was also the magistrate. The rector was out, so the protesting naval officer was locked in an outhouse until he returned. Even then, Revd Polwhele partook of a refreshing cuppa before allowing the prisoner into the house to be interviewed. A by now furious Bligh gave no response to Polwhele's questions, maintaining his silence until his temper had cooled sufficiently and the two men were alone. Eventually Polwhele realised the mistake and, pleased to entertain such a famous guest, both men enjoyed a supper of woodcock, washed down with some fine wines, continuing until two in the morning when they parted the best of friends.

St Anthony borders Gillan Creek on the Helford.

Manaccan.

Revd Densham and His Missing Congregation

In 1931, the remote parish of Warleggan on Bodmin Moor welcomed a new vicar. The son of a Methodist minister, the much-misunderstood Revd William Densham had served for a while as a missionary in South Africa and admired the ideas of Gandhi. A clever and well-educated man, his religious views were more attuned to his Methodist father than the high Anglican tradition he was to find at St Bartholomew's Church in Warleggan. He got off on the wrong foot and, within months of his arrival, received a request from his church council to remove the ducks he was keeping in the church hall and clean up the mess, in order for them to hold a whist drive. This did not go down well, for the rector had a puritanical dislike of whist drives and other forms of entertainment which he called amusements from hell. It also extended to the church organ, which he called a gabled profanity, angering his parishioners further by attempting to sell it. There were soon complaints from them and they unsuccessfully petitioned Bishop Walter Frere for his removal. Daphne du Maurier met Revd Densham at a dinner hosted by Sir Arthur Quiller-Couch, and found him amiable if a little odd. He had advertised for a resident gardener, offering a salary of a penny a year and all his potatoes free. Not surprisingly, he had no applicants. He also kept dogs and was unpopular with local farmers whose sheep they attacked. To prevent this happening again, he fenced the rectory around with barbed wire, misinterpreted as a desire to keep parishioners out. They were also asked to make an appointment in writing to see him, and on arrival, bang an oil drum placed at the rectory gate. He frequently preached to an empty church, recording on one occasion 'no fog, no wind, no rain, no congregation'. According to Daphne du Maurier, he replaced his missing congregation with cardboard cut-outs; this never happened, but the story has stuck. He certainly placed cards in the pews bearing the names of previous rectors, his congregation of ghosts, in his words. In June 1949, the Bishop of Truro paid him a visit after word reached him that Densham had painted the interior of the church in a medieval colour scheme of bright blue and red, and he was forced to pay decorators to repaint the interior in white. His rainbow colour scheme remained at the rectory, where every room had its own biblical theme. Recent work in the church has uncovered some of his paintwork.

He got on better with the Methodists in the parish, in whose chapel he often preached, and he was ahead of his time in this respect. He was good at conducting funerals, attentive to visiting and praying for the sick, taking them flowers and produce from his garden. He shared his wartime rations with the poor, and furnished rooms in the rectory for evacuees, although none were billeted there. With time he became more reclusive. By the early 1950s, when he was in his eighties, his story began to attract interest from journalists, including the American photographer Carl Mydans from *Time Magazine*, whose portrait

Above and below: St Bartholomew's Church, Warleggan. *(Inset)* village sign.

of the old man wearing a broad-brimmed hat and an equally broad grin adorns a booklet available in the church. One day in 1953, after no signs of life were seen in the rectory for several days, entry was forced and his body found inside. Sadly, he was afforded little dignity in death, his body carted away loosely covered and with the feet showing, according to one witness. His funeral was held in Plymouth with only a solicitor present. The rectory was sold and no further rectors were appointed to the living at Warleggan. The 2009 film *A Congregation of Ghosts* dramatised the story, and starred Edward Woodward as Revd Densham, the actor's final role.

The Tintagel Plane Crash

At around 11 a.m. on Friday 6 July 1979, the village of Tintagel narrowly escaped a major tragedy when a pilotless fighter jet crashed within a few yards of the main street, busy with tourists at the time. Miraculously, no one was killed or seriously injured, with the only damage being a few cars destroyed and walls demolished, plus a broken ladder. The pilot of the RAF Hawker Hunter aircraft was on a training flight when he experienced a problem with the aircraft's fuel supply. Losing height and very close to land, he set the 'plane on a course to crash well away from land in the Atlantic before ejecting just in time. He landed safely in the water, and was picked up by a fishing boat, one of whose passengers was the designer of the ejector seat who just happened to be on holiday! The 'plane, possibly as result of the ejection, carried out a U-turn and headed back towards the coast, losing height and on course for Tintagel at 125 knots and armed with high-explosive shells. A resident of Tintagel was on the 'phone to a TV repairman at the time, who was no doubt shocked to hear him say that he had to ring off as a 'plane was headed straight for him! Even more surprised was a lady hanging out the washing in her garden in King Arthur's Terrace: the 'plane, which had already lost a wing, bounced along the ground just in front of her house and the fuselage wedged itself neatly into the alley between her property (now cleverly renamed *Hunter's Rest*) and the café next door, the remaining wing being sheared off in the process. The nose of the aircraft came to rest in the street just 10 yards from the local garage where a petrol tanker was unloading a delivery of 1,500 gallons of highly inflammable fuel. In the last few seconds of the flight the 'plane had hit a ladder with the tip of its wing, a shock for the resident who was standing on it painting his house, just managing to slide to the ground in time. The jet then collected a garden parasol which remained stuck in the nose cone after it came to rest. Two elderly ladies standing in their garden narrowly escaped death as the 'plane passed just feet above their heads. As one remarked to the other, 'My word, that one was low!' Investigations showed that the cause of the fuel supply problem was a tiny blob of grease which had managed to block a fuel line!

Hunter's Rest, Tintagel, where an RAF jet crashed in 1979.

The Elephant That Swam the Tamar

In July 1923, Bostock and Wombwell's Circus and Menagerie was touring the South West. On the evening of 8 July, a performance took place at Torpoint, just inside the Cornish border on the banks of the Tamar. The following morning the circus was due to return to Devonport via the Torpoint ferry. The animals and wagons were assembled on the bank and the tricky loading operation began, using one of the menagerie elephants, Julia, to provide additional muscle. Once on the ferry, she was tethered to the vessel's deck. Shortly after beginning the crossing, Julia snapped her chain, smashed through the safety gates and plunged into the river. Her keeper watched in horror as she disappeared below the surface and stayed under for more than a minute, before surfacing again, swimming towards Torpoint. On hearing her keeper's voice calling her, she turned and started swimming back towards the ferry, but the current was strong and it was feared that she might be carried away downriver. A steam pinnace was in the vicinity and came alongside the elephant to assist, but the captain of the vessel misunderstood his instructions and began heading Julia back to the Torpoint bank. After her keeper called her back and with the assistance of the steam pinnace, Julia was secured to the boat with a chain and swam all the way across to Devonport.

The Torpoint ferry in the 1920s. (Photo courtesy of Stephen Johnson)

Bibliography

Baring-Gould, S., *Cornish Characters and Strange Events* (London: John Lane, 1909)

Courtney, M.A., *Cornish Feasts and Folklore* (Penzance: Beare and Son, 1890)

Dean, T., and Shaw, T., *The Folklore of Cornwall* (Batsford Ltd, 1975)

Dyer, P., *Tintagel: A Portrait of a Parish* (Cambridge: Cambridge Books, 2005)

Grigg, C., *The Story of Leek Seed Chapel, St Blazey Gate Cornwall* (St Blazey: Osborne Press, 1974)

John, C.R., *The Saints of Cornwall* (Padstow: Lodenek Press, 1981)

Larn, R. and Larn, B., *Henry Trengrouse the Cornish Inventor of the Rocket Life-saving Apparatus* (Truro: Truran Books Ltd, 1975)

Van der Kiste, J. and Sly, N., Cornish Murders (Stroud: Sutton Publishing, 2007)

Vivian, C., *A short history of Bishop Trelawny's Life 1650 – 1721* (Self-published, 2021)

Acknowledgements

I am grateful to Jenny Bennett from Amberley Publishing for her editorial guidance. Most of the photographs are my own, and I thank all the property owners for permission to reproduce those taken at privately owned locations. I also thank Mike Ellis (Mousehole Christmas lights), Stuart Hughes (Skinners Brewery), Liz Heavey (Light Regional Council, South Australia) and Stephen Johnson for allowing me to use their photographs and illustrations. Special thanks are due to Colin Grigg (Leek Seed chapel). I am also grateful to the staff at Cornwall Record Office (Kresen Kernow) for the use of their library.

About the Author

John Husband grew up in the Cornish village of Gorran Haven and has lived all his life in the county. He has a PhD in Paper Science from the University of Manchester and is a Fellow of the Technical Association of the Pulp and Paper Industry and a member of the Royal Society of Chemistry. A self-taught photographer and writer, he has written articles for *The Lady, The Countryman, This England, Evergreen* and *The People's Friend,* and this is his third book for Amberley Publishing.